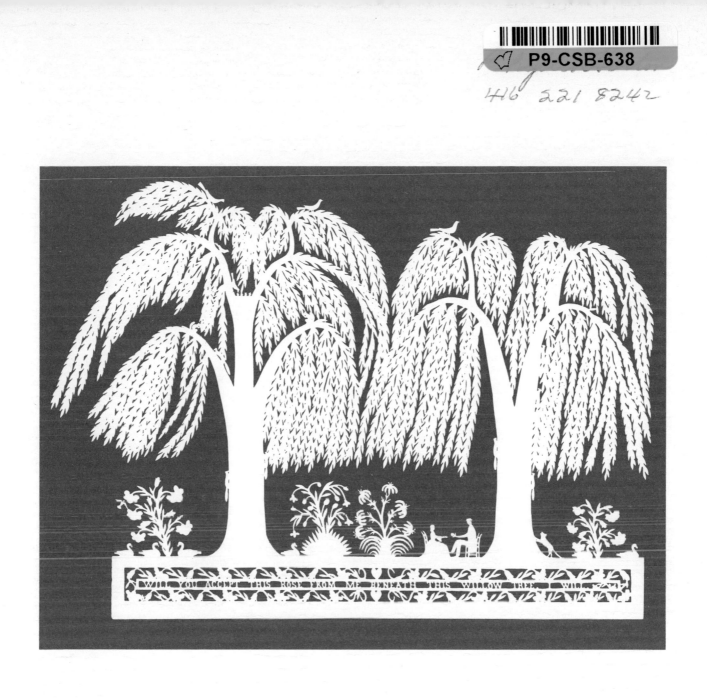

FOLK TREASURES
OF HISTORIC ONTARIO

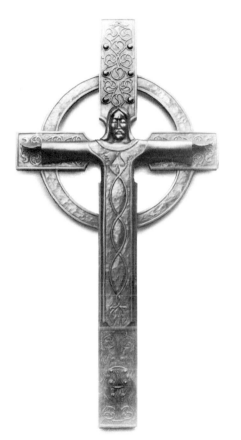

FOLK TREASURES
OF HISTORIC ONTARIO

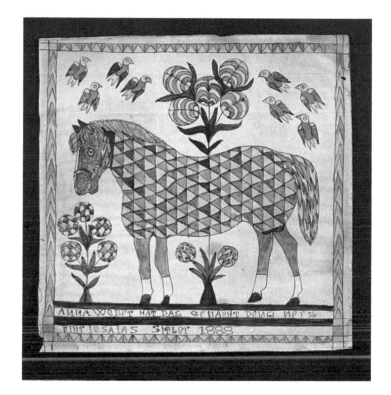

Terry Kobayashi, Michael Bird
Elizabeth Price

Presented by the Ontario Heritage Foundation,
Ontario Ministry of Citizenship and Culture in association
with the Robert McLaughlin Gallery, Oshawa

Published by
The Ontario Heritage Foundation
77 Bloor Street West, 2nd Floor
Toronto, Ontario M7A 2R9

The Ontario Heritage Foundation is an agency of the
Ontario Ministry of Citizenship and Culture. Guided
by a board of some thirty private citizens, the Foundation
is dedicated to fostering wider appreciation of Ontario's
rich heritage and stimulating greater public participa-
tion in the preservation of the province's historical and
cultural resources. It provides grants for archaeological
excavations, architectural and historical restorations,
heritage publications and innovative regional projects.
The Foundation also erects commemorative markers
and, through its Trust program, acquires and maintains
real properties and natural areas of outstanding signif-
icance and accepts gifts of art on behalf of the
people of Ontario.

Canadian Cataloguing in Publication Data

Kobayashi, Terry, 1939-
 Folk treasures of historic Ontario
ISBN 0-7743-9876-0
1. Folk art – Ontario – Exhibitions. 2. Decorative arts –
Ontario – Exhibitions. I. Bird, Michael S., 1941-
II. Price, Elizabeth. III. Ontario Heritage Foundation.
IV. Title.
NK841.K6 1984 745′.09713′074011356 C85-093001-4

Editor: Mary Ellen Perkins
Design & Production: R.K. Studios Limited
Typesetting: McGill Productions
Colour Separation: Graphitech Inc.
Printing & Bindery: The Bryant Press Limited

Contents

Exhibition Schedule

Robert McLaughlin Gallery, Oshawa
Tuesday, January 8 – Sunday, January 27, 1985

Art Gallery of Windsor, Windsor
Sunday, February 17 – Sunday, March 17, 1985

Macdonald Stewart Art Centre, Guelph
Saturday, March 23 – Sunday, April 21, 1985

The Gallery/Stratford, Stratford
Monday, May 27 – Sunday, August 11, 1985

Laurentian University Museum
and Arts Centre, Sudbury
Wednesday, August 28 – Sunday, September 22, 1985

Ontario Science Centre, Toronto
Monday, October 14 – Saturday, November 23, 1985

Rodman Hall Art Centre and National
Exhibition Centre, St. Catharines
Friday, December 6, 1985 – Sunday, January 5, 1986

Thunder Bay National Exhibition
Centre and Centre for Indian Art,
Thunder Bay
Thursday, January 23 – Sunday, March 2, 1986

*Some artifacts may not be exhibited
in all of the above centres.*

Acknowledgements

A project of this magnitude comes to fruition only through the dedication and enthusiastic assistance of many individuals.

The organizers would like to thank Bernice Bradt of the Robert McLaughlin Gallery, Oshawa for her constant counsel and support, and Mary Ellen Perkins for her thoughtful and valuable editorial work. The efforts of Rachel Atlas and Renni Wilmot in the organization of the exhibition are also warmly appreciated.

The insight and professionalism brought to the design and production of this catalogue by Ron Kaplansky make us exceedingly grateful to him.

We are indebted to the curators and staff of many galleries, museums and archives for their assistance in the project. Special thanks are due to Joan Murray who greeted the initial idea for the exhibition with enthusiasm. Those who offered help in research include, among others, Carl Benn, Martin Broadhead, Susan Burke, Russell Cooper, Dr. Norman Green, Dr. Ralph Lebold, Marten Lewis, Sandra Overstrom, Nelson Scheifele, Samuel Simchovitch, Barbara Snyder, Sam Steiner, Liza Whealy and William Yeager.

As well, we wish to thank the museums and art galleries who chose to host the exhibition.

Finally, we would like to express our sincere appreciation to the private collectors and museums who agreed to lend artifacts. Without their generosity and patience *Folk Treasures of Historic Ontario* could not have been mounted.

Minister's Message

Folk Treasures of Historic Ontario celebrates a unique form of creative expression.

Hundreds of folk artists in 19th century Ontario lacked the luxury of academic training and, because of economic, cultural or social circumstances, did not gain widespread recognition. Still their legacy – spirited works of every conceivable description – is impressive.

The range of cultural inspiration for these startling works is as varied as the modes of expression. From early settlers to more recent immigrants, Ontario's folk artists have used design traditions brought from their homelands, ingeniously adapting them according to lifestyles established here.

Folk Treasures of Historic Ontario pays tribute to the creative imagination of these artists and attests to the vitality of the cultural communities in which they worked. As minister responsible for heritage, multiculturalism and the arts, I am privileged to share the many treasures in this memorable exhibition with my fellow Ontarians.

Susan Fish
Minister
Ministry of Citizenship
and Culture

Chairman's Message

With the exception of several studies devoted to highlighting Ontario-German decorative traditions, historic folk art has not received the attention it merits. The Ontario Heritage Foundation has mounted *Folk Treasures of Historic Ontario* in an attempt to increase public appreciation of the wealth of cultural expression left us by folk artists working in the late 19th and early 20th centuries.

Over 200 artifacts drawn primarily from private collections are included in the exhibition. They were chosen from an astonishing array of works because of their cultural significance and their aesthetic appeal, and they represent a wide range of the media in which folk artists displayed their creative energies.

These objects were made by ordinary men and women usually for their own use and enjoyment. They tell a little-chronicled story of humble backgrounds, simple lifestyles and respect for tradition and, in this, they provide a glimpse of life in early Ontario.

It is my hope that *Folk Treasures of Historic Ontario* will help to establish folk art as a valid and vital resource in the examination of our cultural heritage

John White
Chairman
Ontario Heritage Foundation

Introduction

Folk art excites the eye, lifts the spirit and touches the heart. One cannot fail to be attracted by its familiar forms and charmed by its distinctive beauty. Equally appealing is its vitality. Whether whimsical or serious, simple or expertly crafted, it is characterized by spontaneity and exuberance. Indeed, in all of its many forms – from whirligigs to watercolours, pottery to quilts, toys to kitchen utensils, hooked rugs to furniture – folk art is highly expressive work.

Folk art is also a compelling social document. The product of ordinary people of varying degrees of skill and artistry, it reflects the place and time that gives rise to it. Folk artists, be they farmers or housekeepers, have always been deeply rooted in a matter-of-fact present, and they have borrowed from and responded to sources and subjects in the culture that surrounds them. The objects they create reflect prevalent attitudes, tastes and beliefs, and provide glimpses of a community's way of life.

As is evident in *Folk Treasures of Historic Ontario*, our province possesses a rich folk art heritage. This is the legacy of the artistic vitality of individuals and groups working primarily in the 19th century. During that time immigrants from many lands settled in Ontario, joining the native peoples who had long lived here. High hopes for economic prosperity, religious freedom and social stability compelled them to face the uncertainties of life in a new land. Their immediate needs were simple: gathering and preserving food, building homes, keeping warm, caring for their children, and providing a place of worship. Articles of daily use were fashioned primarily with an eye for practicality. Yet, it was in these austere circumstances that Ontario's earliest folk art was produced. In a wonderful assimilation of creativity and expediency, gentle curves and rich glazes were added to jugs and bowls, accents of colour and design were added to quilts and hooked rugs, and ornamental carving and flourishes were added to tables and chests. Time and time again, Ontario's first folk artists responded to necessity by fashioning things in a manner that went well beyond "making do". Amidst the drudgery of pioneer life, they aspired to create beauty in the most modest of objects.

The folk art which grew to meet the utilitarian needs of the New World was shaped by traditions carried over from the Old. Immigrants brought with them their own artistic heritage. Faced with the almost overwhelming challenge of adapting to new circumstances, folk artists attempted to surround themselves

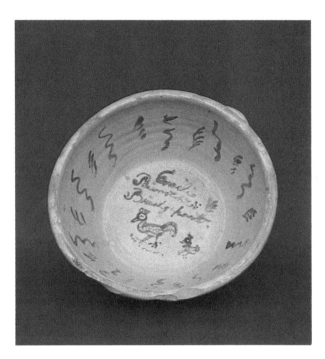

with familiar possessions, objects which recalled their heritage. Cultural isolation allowed many of them to continue producing objects in traditional decorative styles long after these styles had gone out of fashion in their homelands.

A variety of peoples settled in Ontario – Natives, French, English, Germans, Poles, Jews, Ukrainians and Russians to name but a few. The diversity of their cultural backgrounds led to the development of distinctive folk art traditions. As a result, Ontario folk art is a spirited reflection of many cultural ideas and tastes.

Folk Treasures of Historic Ontario is a celebration of this dynamic aspect of our cultural heritage. The Native tradition is revealed in the otter, swan and duck handles on carved ladles; the French, in the chalice and other religious motifs on a carved walking stick; the English, in the sampler-like designs on an embroidered quilt; the Polish, in the stencilled floral decoration on a storage chest; the Jewish, in the symbols of fertility bordering a marriage certificate; the Ukrainian, in the geometric designs on painted eggs; and the German, in the symmetrically arranged birds, hearts and tulips on several drawings, hooked rugs and quilts.

Although rooted in particular cultures or traditions, Ontario folk art is enriched by personal interpretation, inventiveness and inspiration. Ingenious work, it may reveal an inclination towards humour, the hope of conveying affection to a loved one or an urge to preserve past memories. Many items shown here are examples of this individual spirit. They include a tin weathervane with the provocative silhouette of a mermaid-pirate, raised sword in hand; a charming cross-legged angel painted by Joseph Bauman for his beloved daughter, Maria; and a box with flags, beavers and inscriptions decorated by Alexander McNeilledge in a blaze of patriotic zeal to celebrate Confederation.

A unique blend of the traditional and the innovative, Ontario folk art is indeed dynamic and stunning in its diversity. *Folk Treasures of Historic Ontario* serves as a testament to this rich heritage.

15

CHAPTER ONE
GRAPHIC WORKS

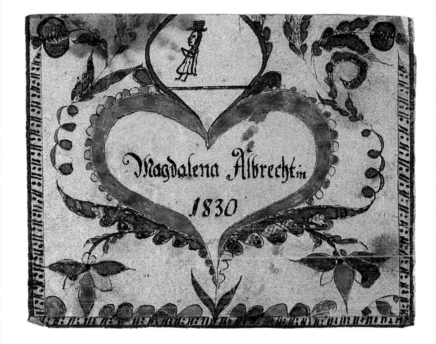

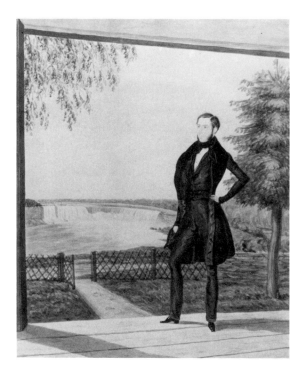 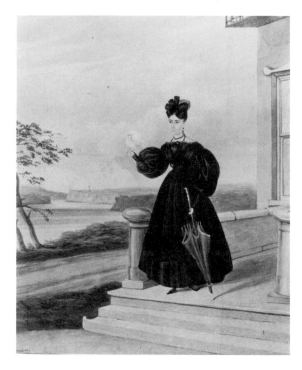

1 Richard Wagstaffe, Esq.
 G. D'Almaine (d.1893)
 Niagara-on-the-Lake, 1834
 Watercolour on paper
 43 x 33 cm
 Niagara Historical Society Museum,
 Niagara-on-the-Lake

2 Emma Wagstaffe
 G. D'Almaine (d.1893)
 Niagara-on-the-Lake, 1834
 Watercolour on paper
 43 x 33 cm
 Niagara Historical Society Museum,
 Niagara-on-the-Lake

In the style of European portraitists, artists in Upper Canada often attempted to ennoble their subjects by depicting them in situations of apparent wealth and status. D'Almaine has made full use of this practice in these two portraits: the magnificent Niagara Falls serve as a mere backdrop for a splendidly self-confident Richard Wagstaffe, and his daughter, Emma, appears quite oblivious to the rushing cataract of the Niagara River at Queenston depicted behind her.

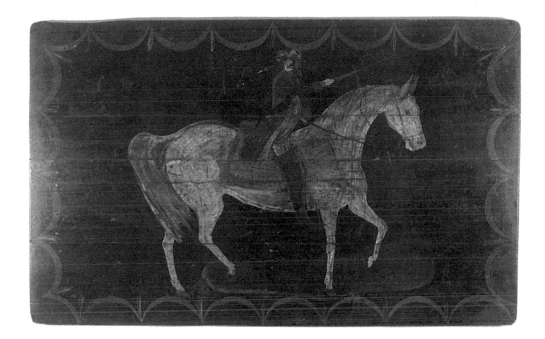

3 King Billy
Anonymous
Orangeville, second half
of the 19th century
Oil on wood
86 x 139 cm

William III, stadholder of the United
Provinces of the Netherlands, and King of
England from 1689 to 1702, was the subject of
many heroic portraits. These portraits, in
turn, inspired countless imitations by lesser
artists and craftsmen. This depiction of "King
Billy," painted on a tabletop in an Orange-
men's Hall, appears to have been adapted from
a Currier and Ives print popular at the time.

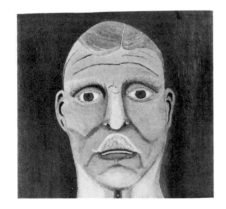

**4 A Modern Briton,
A Self Portrait**
Joseph Bradshaw Thorne
(1869-1963)
Toronto, 1928
Oil on canvas
26 x 28 cm

**5 The Ancient Briton,
A Self Portrait**
Joseph Bradshaw Thorne
(1869-1963)
Toronto, 1961
Oil on canvas
46 x 31 cm

Joseph Thorne was born in working-class London and died, a loyal Briton still, in working-class Toronto. His striking self portraits, from which he gazes confidently out at the world, remain as testaments to his long, eventful life. An exuberant and unselfconscious artist, Thorne often felt compelled to decorate the backs of his canvases with painted text. On the reverse side of "The Ancient Briton," for instance, is inscribed:

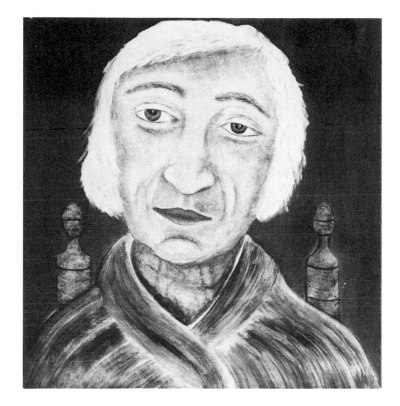

Painted By Joseph Bradshaw Thorne
In His 90 Second Year …
In Painting This Picture I Used A Looking
Glass Compas And Rule
In 1905 I Was Working …
I Struck A
Large Flat Rock Under The Earth
Broke The Steeel Nose Off The
Plough It Fell Back And Struck
Me On The Head That Accounts
For The Scars On The Picture.

6 Listening to the News,
 A Self Portrait
Hertha Muysson (b.1898)
Guelph, c.1970
Oil on canvas
30.5 x 30.5 cm

While listening to news of severe flooding in
her native Holland, Hertha Muysson appar-
ently caught sight of her reflection in a mirror.
Years later, the distress and sadness of that day
found expression in this arresting self portrait.
The full-face pose and solid-colour back-
ground contribute effectively to the quiet
intensity of this remarkable painting.

21

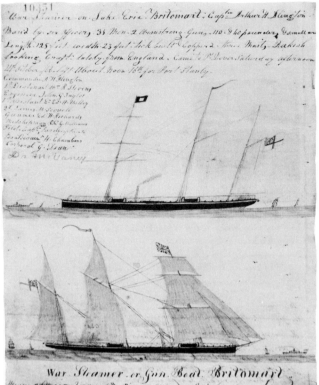

7 Ship's Logbook
Alexander McNeilledge (1791-1874)
Philadelphia, 1810-11
Ink, graphite and watercolour on paper
33 x 20.5 cm
Eva Brook Donly Museum, Simcoe

A Scottish sea-captain operating out of
Philadelphia, Alexander McNeilledge
travelled about the world for several years.
In 1830 he settled in the tiny village of Port
Dover on Lake Erie. On his voyages to Cathay,
the Cape of Good Hope and South America
he kept extensive logbooks in which he
recorded everyday weather conditions as well
as dramatic events. Interspersed among these
lengthy descriptions are delicate, highly
detailed drawings of sailing ships – some based
on actual observation, others copied from
lithographs.

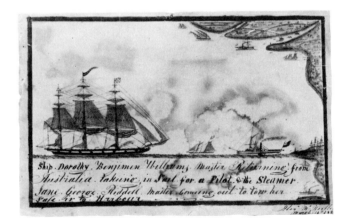

8 Clipper Ship Dorothy
Alexander McNeilledge (1791-1874)
Port Dover, 1854
Watercolour and ink on paper
13 x 21 cm
Eva Brook Donly Museum, Simcoe

An unsuccessful miller and disinterested
farmer, Alexander McNeilledge was,
nevertheless, a highly imaginative, utterly
uninhibited folk artist. As tokens of friend-
ship, he made drawings such as this one for the
Williams family in which he named the vessel
after the wife, Dorothy, the captain after the
husband, Benjamin, and the smaller boats
after the children. Captions describing fic-
tional voyages and unlikely cargoes were
included at the bottom and brief statements
of affection were frequently inscribed
on the back.

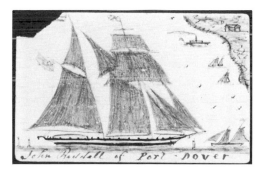

9 Free Trade and Sailors' Rights
Alexander McNeilledge (1791-1874)
Port Dover, 1866
Watercolour and ink on paper
13 x 20 cm

A retired sea-captain who spent much
of his idle time in conversation with
friends and visitors, Alexander
McNeilledge had keen political
interests which led him to comment
on many issues of the day. His views on
mercantile policy, his loyalty to Great
Britain, and his endorsement of basic
Christian virtues all find expression in
this lively compilation of flags, ships
and mottoes.

10 Small Ship
Alexander McNeilledge (1791-1874)
Port Dover, 1869
Watercolour and ink on card
6 x 9 cm
Eva Brook Donly Museum, Simcoe

Unable to leave any piece of paper undeco-
rated, Alexander McNeilledge made numer-
ous sketches on calling cards. Drawn for the
entertainment of his friends, these small
works are similar in format and spirit to the
larger paintings. On the back of this card,
given to a neighbour, John Riddell, the artist
has inscribed: "use no Specks. Never Smoked
a Pipe or Chewed Tobacco. Take a Wee Drop
Occasionally."

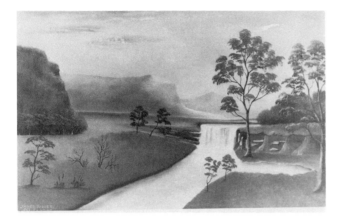

11 Untitled Landscape
James Beaver
Brantford area, late 19th century
Oil on canvas
66.5 x 92 cm

During his youth on the Six Nations Reserve near Brantford, James Beaver appears to have taught himself how to paint by imitating scenes on calendars and in magazines. Though relatively unconcerned with perspective and overall composition, he shows considerable skill in the refinement of isolated details and the deft handling of colour in his depiction of natural subjects.

12 Garden Setting
E. Tweedie
Southwestern Ontario,
late 19th century
Oil on canvas
56 x 90 cm

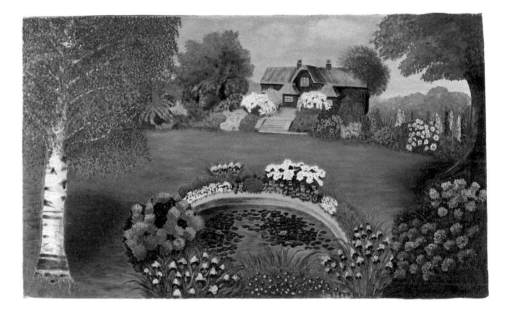

A sense of English romanticism characterizes this charming, unsophisticated work. Its subject, ordered nature, is exemplified in the planned arrangements of trees and flowers in the Victorian garden.

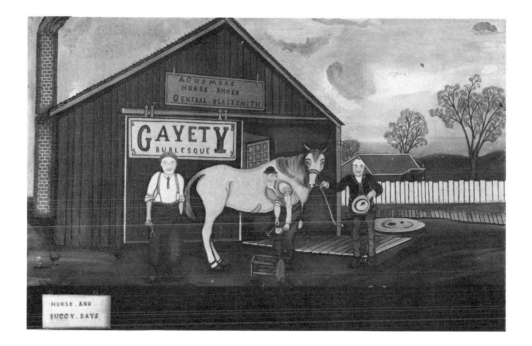

13 Horse and Buggy Days
Joseph Bradshaw Thorne (1869-1963)
Toronto, c.1935
Oil on canvas
39 x 71 cm

Throughout his long life in England and
Toronto, Joseph Thorne painted scenes of
local colour and community activity. His love
of life, people and painting are evident in this
comical narrative picture of Mr. Johnes shoe-
ing his horse at Cudmore's Blacksmith Shop
in east Toronto.

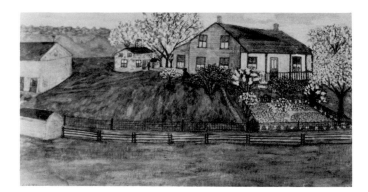

14 North Woolwich Homestead
Leah Daum (1896-1979)
Elmira, c.1945
Oil on cardboard
30 x 55 cm

A composite of nostalgic memories from childhood, this harmonious scene portrays the four-square garden, bank barn and tidy homestead typical of a 19th-century Pennsylvania-German farm. The idealized landscape creates a mood of stillness and serenity, qualities often associated with a traditional Mennonite upbringing – a heritage the artist was keen to record.

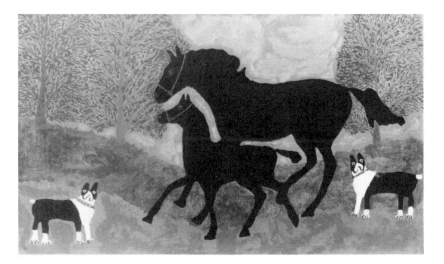

15 Horses and Dogs
Mary Francis (1900-1979)
Picton, c.1950
Oil on masonite
36 x 58 cm

Particularly fond of animals and plants, Mary Francis seems to have taught herself to paint by calmly observing and recording her favourite pets and garden flowers – subjects she rendered, surprisingly, on sheets of masonite using old house paints.

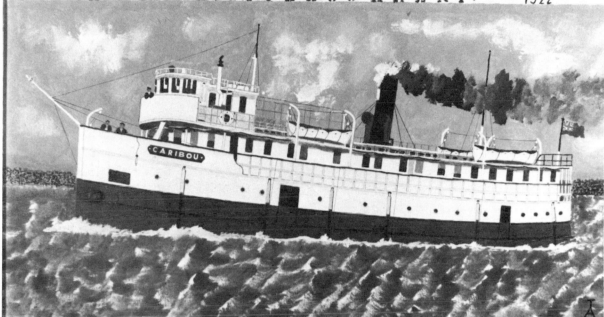

16 Sat. Caribou At Little Current 1922
 Angus Trudeau (1905-1984)
 Georgian Bay area, c.1960
 Acrylic on canvas
 50 x 105 cm
 National Collection, Indian and Northern Affairs

Georgian Bay long held a fascination for Angus Trudeau, an Odawa Indian. While employed in lumber camps and on lake freighters he lived along its shores, and after his retirement he delighted in painting brilliantly coloured "portraits" of the many ships plying its waters. Here, as in many of his other works, Trudeau used a stencil technique to place a title at the top of the picture.

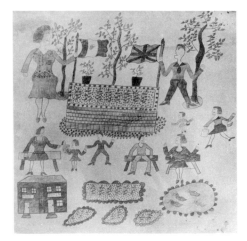

17 Centennial Garden Party
Clarence Webster (b. c.1900)
Toronto, c.1975
Felt marker on paper
76 x 78 cm

Following his confinement to a Toronto nursing home,
Clarence Webster began to produce vibrant, highly
individual drawings, some directly on the walls of his
room, others on materials given him by nurses. In this
particular work, Webster has used a traditional folk art
technique, showing various scenes simultaneously in
one action-filled composition.

18 Home of Cornelius
and Ida Hildebrandt
Henry Pauls (b.1904)
Blytheswood, c.1980
Oil on canvas
40 x 60 cm
*Conrad Grebel College,
Waterloo*

In the aftermath of the Revolution of 1917, Henry Pauls
was forced, along with other Mennonites, to leave his
home in Russia. Possessed of a keen historical interest,
he decided, decades later, to use painting as a means of
recording and dramatizing events in his early life. This
large, vivid canvas memorializes the tranquility of farm
life in southern Russia before the political upheavals of
the early 20th century.

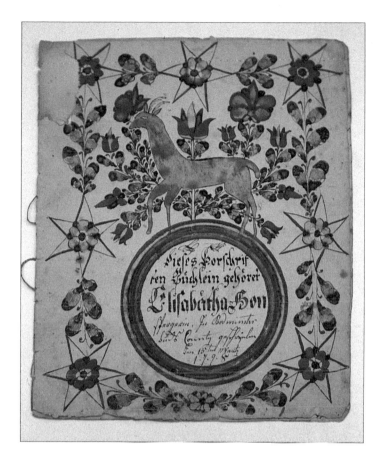

19 Writing Exercise Booklet
 Anonymous
 Pennsylvania, 1798
 Watercolour and ink on paper
 20 x 16 cm

20 Baptismal Record
 Anonymous
 Alsace, 1832
 Watercolour and ink on paper
 22.5 x 17.5 cm

Fraktur, the art of decorative calligraphy, had
its origins in Switzerland and the Rhineland
Palatinate and achieved a splendid flowering
in Pennsylvania during the 18th and 19th cen-
turies. Specimens brought to Upper Canada
by Pennsylvania-German and Continental-
German immigrants served as prototypes for
later pieces as well as family mementoes.
These two examples – a *Vorschrift* or writing
exercise booklet from Pennsylvania and a bap-
tismal record, probably Alsatian in origin –
exhibit the type of exuberant embellishment
which characterized the drawings of *Fraktur*
artists working in Ontario.

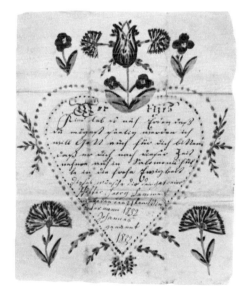

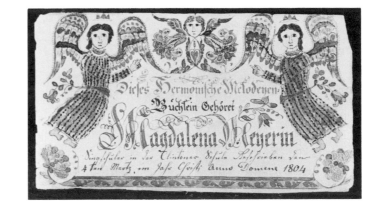

21 Songbook
Anonymous
Niagara area, 1804
Watercolour and ink
on paper
9 x 16.5 cm
*Jordan Museum of
the Twenty, Jordan*

22 Songbook
Anonymous
Niagara area, 1834
Watercolour and ink
on paper
8.5 x 14.5 cm
*Jordan Museum of
the Twenty, Jordan*

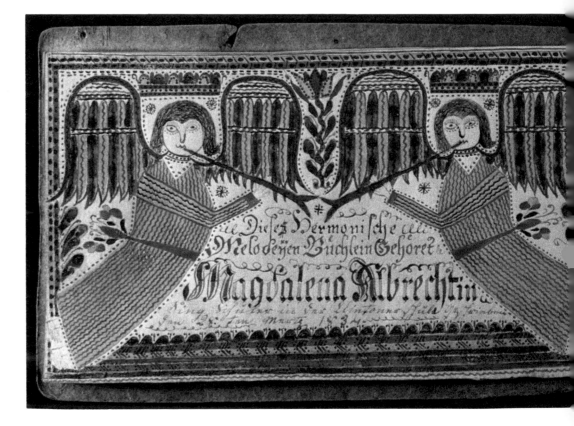

These early songbooks, evidence of the active musical life in 19th-century Mennonite communities, have luxuriantly decorated title pages. The paired angels are an ancient Christian motif that was adapted from Roman funerary art and eventually used by folk artists in the Swiss-German regions of Europe.

23-26
Drawings
Anonymous
Niagara area, 1804,
1830, undated
Watercolour and ink
on paper
8.5 x 10.5 cm
11.5 x 7 cm
16.5 x 9.5 cm
12.5 x 6.5 cm
*Jordan Museum of the
Twenty, Jordan*

The festive, symmetrically arranged birds and
flowers which dominate these charming draw-
ings are stylized motifs typical of Pennsylvania-
German folk art in the late 18th and early
19th centuries. The whimsical drawings of a
little girl above the heart and a young woman
in a bower are, however, rare features in
Mennonite *Fraktur.*

 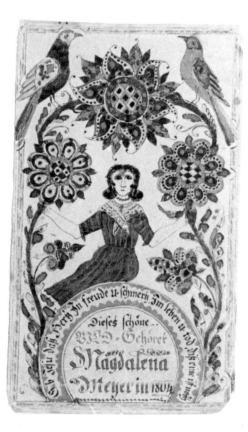 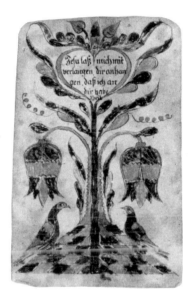

33

27 Writing Exercise
Anonymous
Vineland area, 1811
Watercolour and ink
on paper
20 x 23.5 cm
Jordan Museum of
the Twenty, Jordan

The *Vorschrift* or writing exercise was an art
form that flourished in Pennsylvania-German
communities in Ontario. As exemplified here,
it consisted of a text, usually a Scriptural
maxim, finely lettered and decorated by a
schoolmaster for imitation by his pupils. This
outstanding specimen features both printed
and cursive text, followed by alphabets and
numerals.

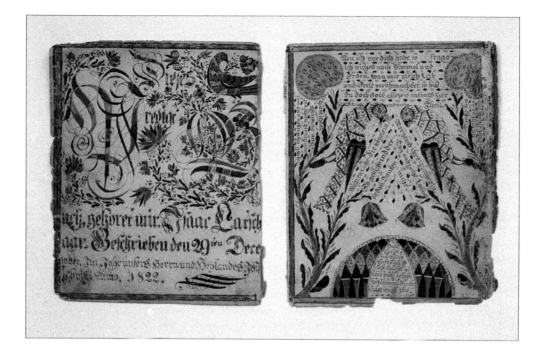

28-29
Bookplates
Abraham Latschaw (1799-1870)
Waterloo County, 1822
Watercolour and ink on paper
Each 20 x 17 cm

The earliest known *Fraktur* in Waterloo
County are these elaborate bookplates
inscribed by Abraham Latschaw for his
younger brother Isaac. The masterful
illumination of the religious text and
the sophisticated incorporation of an
array of floral and geometric design
motifs indicate the exceptional skill of
this artist.

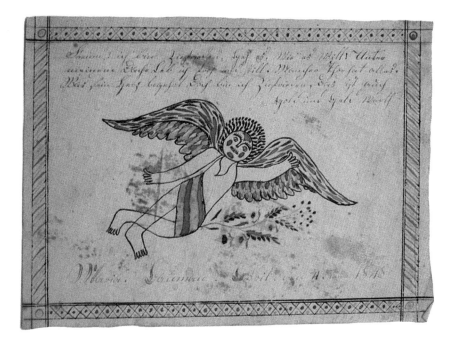

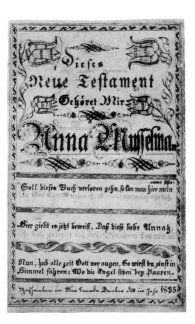

30 Bookplate
 Isaac Z. Hunsicker (1803-1870)
 Waterloo County, 1835
 Watercolour and ink on paper
 18 x 11 cm

Possibly the most prolific *Fraktur* artist in Waterloo County, Isaac Hunsicker produced countless bookplates, birth certificates, marriage records and family registers. This early composition, a bookplate for Anna Musselman, is distinguished by meticulous calligraphy, and crisply drawn tulips and decorative border. Combined with the religious text are practical directions for returning a lost book to its owner.

31 Angel
 Joseph Bauman (1815-1899)
 Waterloo County, 1848
 Watercolour and ink on paper
 9.5 x 15 cm

Though Joseph Bauman's delightful cross-legged angel, painted for his first child, Maria, is a folk art modification of a classical cherub, it was likely inspired by a motif popularly employed in Pennsylvania-German baptismal records.

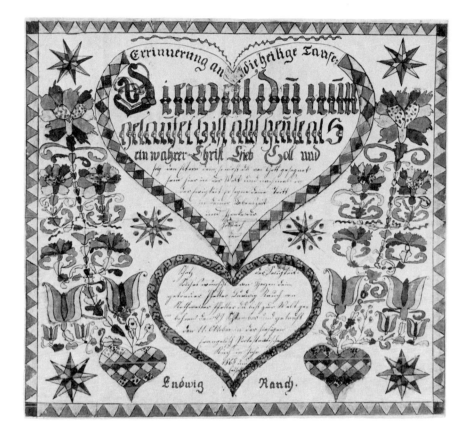

32 Baptismal Record
Ludwig Rauch
Welland County, 1868
Watercolour and ink
on paper
30 x 32 cm

In this unusually large, lavishly decorated baptismal record, a central text enclosed in hearts is flanked by eight-sided stars and a profusion of flowers. A traditional *Fraktur* piece, it was done entirely by hand for or by Ludwig Rauch, a German immigrant. It may have been derived from contemporary printed forms which by this time were beginning to supplant much individual craftsmanship.

33 Adam and Eve

Joseph Bauman (1815-1899)
Waterloo County, c.1870-1880
Ink on paper
60 x 41 cm

Joseph Bauman, one of the last prac-
tising *Fraktur* artists in Ontario,
made many drawings for his grand-
children and relatives, and inscribed
genealogies in family Bibles for his
neighbours. Occasionally his work
combines traditional elements with
more modern forms. Here, for
instance, the Biblical scene, decora-
tive borders and corner motifs have
been drawn by hand around a com-
mercially printed text.

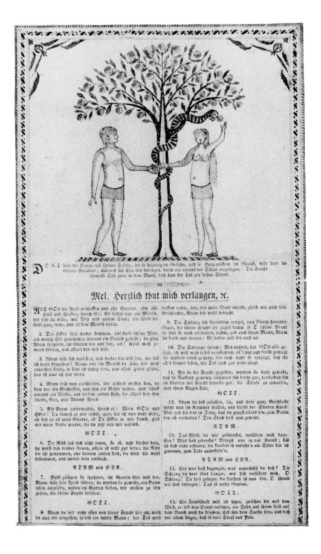

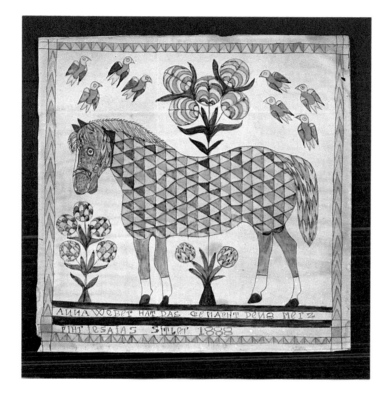

34 Horse
 Anna Weber (1814–1888)
 Waterloo County, 1888
 Watercolour and ink
 on paper
 29.5 x 30 cm

An inventive and remarkably productive Mennonite folk artist, Anna Weber appears to have been a rather disconsolate soul who suffered from various physical afflictions and periods of depression. Her many watercolours demonstrate, however, a joyful affinity with the natural world. In this splendid example of her work, she has combined a sensitive, individual rendering of a horse with traditional Pennsylvania-German motifs of birds and flowers.

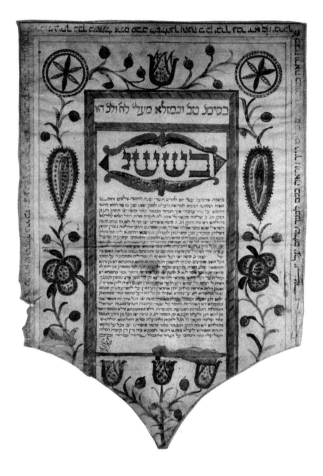

35 Marriage Contract
 Anonymous
 Rome, 1808
 Watercolour and ink on paper
 71 x 48 cm
 Beth Tzedec Congregation,
 Toronto

36 Marriage Contract
 Sharon Binder
 Toronto, 1977
 Ink on paper
 47 x 38 cm
 Beth Tzedec Congregation,
 Toronto

This Italian *Ketubah* is a traditional Jewish
marriage contract with hand-lettered text
elaborately framed by stylized flowers and geo-
metric designs. The modern *Ketubah*, more
sophisticated and original in design, retains
the traditional format, incorporating into the
decorative border various symbols of fertility.

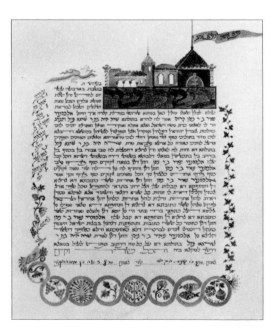

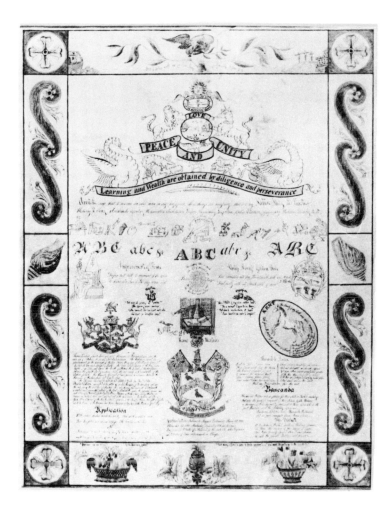

37 Testimonial
Josephus Watson
York County, 1857
Watercolour and ink
on paper
48 x 38 cm

Following the Rebellion of 1837,
Josephus Watson was charged with
treason and imprisoned. Much to his
surprise, he was pardoned. Twenty
years later he recalled the ordeal and
other events of his life in this hand-
lettered and decorated testimonial.

39 Hen on Nest
Josef Drenters (1929-1983)
Rockwood, c.1970
Oil on glass
19 x 24.5 cm

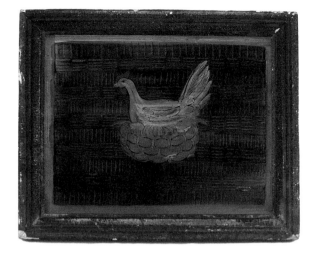

Reverse painting on glass gained immense popularity and achieved a high degree of refinement in Europe during the early 19th century. Josef Drenters, a self-taught sculptor and painter, experimented with glass painting techniques in recent years, and in his sensitive rendering of a common broody hen brought a freshness and vitality to this very old art form.

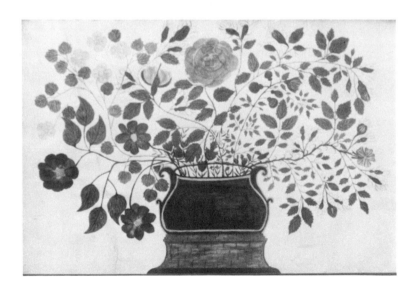

38 Vase of Flowers
Sarah Minerva Roys
Stormont County, mid-19th century
Watercolour on paper
37 x 56 cm
Upper Canada Village, Morrisburg

In New England and eastern Canada during the 19th century, fashionable young ladies were expected to master the "polite arts" in preparation for a refined adult life. Among their accomplishments were theorems, or stencil paintings, of which this pleasant composition is a fine example. Despite the rigidity inherent in the stencil technique, individual expression is evident in the balanced arrangement of details, the addition of freehand drawing, and the sensitive use of colour.

40 Paper cutting
 Anonymous
 Western Ontario, mid-19th century
 Cut paper
 24 x 19 cm
 Joseph Schneider Haus, Kitchener

41 Paper cutting
 Anonymous
 Waterloo County, mid-19th century
 Cut paper
 18 x 29 cm

The Pennsylvania-German tradition of paper cutting was an art form that not only tested the nimbleness of the artist's fingers, but also demanded a strong sense of design and composition. These two examples, each cut from paper folded vertically, indicate the variety of effects possible.

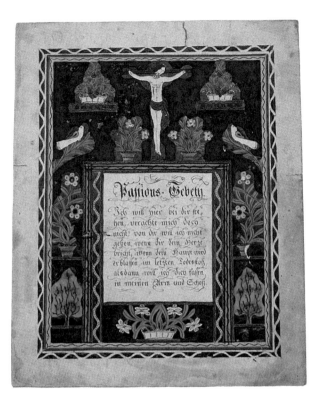

42 Paper cutting
Anonymous
Paris, mid-19th century
Watercolour and ink
on cut paper
32.5 x 33 cm

This ornate, elaborately coloured
valentine with cut-out hearts and
expressions of love recalls another tradi-
tional Pennsylvania-German art form,
Fraktur.

43 Paper cutting
Anonymous
Waterloo County, mid-19th century
Watercolour and ink on cut paper
21 x 16 cm

Magnificent colour and meticulous
cut-work distinguish this piece as
one of the truly superb examples of
its genre. The German text, a con-
soling meditation on the suffering
and death of Christ, is the second
verse of the hymn O *Sacred Head
Now Wounded.*

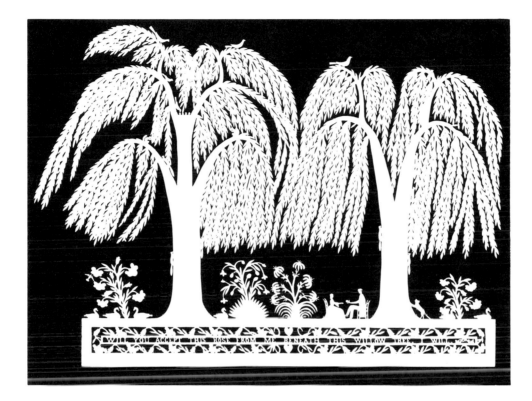

44 Paper cutting
 Anonymous
 Jordan, mid-19th century
 Cut paper
 34 x 46 cm

A *tête-à-tête* in the garden, this delicate paper cutting was undoubtedly made as a token of love. The detail and refinement of the cut work are astonishing. While an idyllic courtship scene is enacted under towering willows, a dog playfully chases squirrels up the tree. Beneath all this activity is the text: "Will You Accept This Rose From Me Beneath This Willow Tree. I Will." All in all, the piece is an outstanding example of Victorian sentiment expressed in a popular North American art form.

CHAPTER TWO
TEXTILES

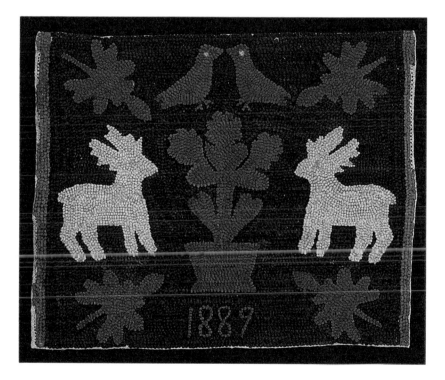

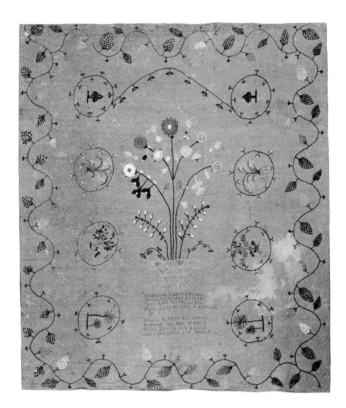

45 Quilt

Mary Dickson
Atwood, 1897
Wool on cotton
201 x 166 cm

Though initially utilitarian objects, quilts were transformed into a unique folk art form in North America during the 19th century. This striking example was stitched by Mary Dickson for the occasion of her marriage in 1897. With its embroidered text surrounded by trees and flowers and its undulating border of vines and grapes, it resembles a large sampler. The centre-piece is a basket of flowers, a design apparently inspired by quilts from New England.

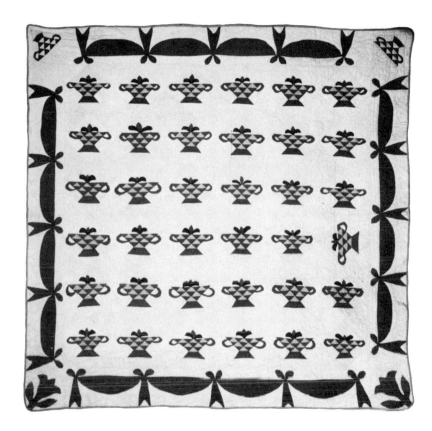

46 Quilt

Anonymous
Hamilton, 19th century
Pieced and appliquéd
cotton
188 x 188 cm

The creation of patterns as well as the actual piecing of quilts required a complex series of sophisticated artistic decisions regarding colour, shape and design. In choosing to work rows of yellow and dark red baskets within a border of neo-classical swags, the maker of this quilt has drawn upon American decorative traditions. Note that one basket has been placed sideways intentionally. The quilter apparently ascribed to the popular belief that to stitch a perfect piece would be a form of vanity.

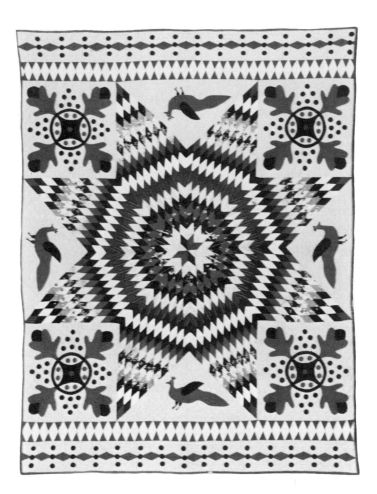

47 Quilt
Anonymous
Perth County,
late 19th century
Pieced and appliquéd
cotton
198 x 148 cm

In this exceptional quilt, innumerable diamond-shaped pieces radiate from the centre to create a dramatic eight-sided star. The quilt reflects a high degree of artistry, not only in the precise way in which the pieces have been cut and stitched, but also in the effective use of colour to accentuate the design. Several motifs – birds and geometric elements – suggest the influence of Pennsylvania-German folk art traditions.

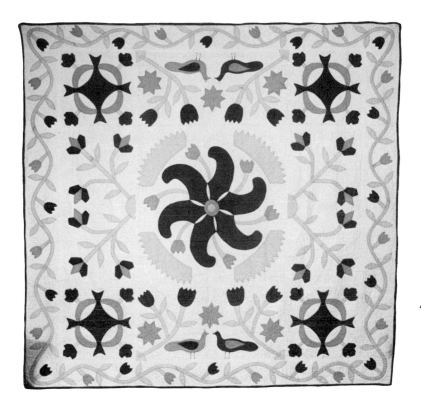

48 Quilt
 Elizabeth Jungblut
 (1877-1964)
 Listowel area, c.1900
 Appliquéd cotton
 197 x 205 cm

The lively, free expression achieved here by the imaginative use of stylized Pennsylvania-German folk motifs attests to Elizabeth Jungblut's exceptional skill as a folk artist. The grace and movement inherent in the design, and the vivid colours in which it has been worked contribute to the quilt's strong visual appeal.

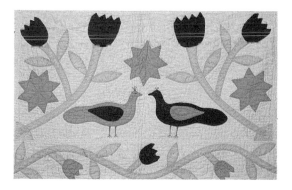

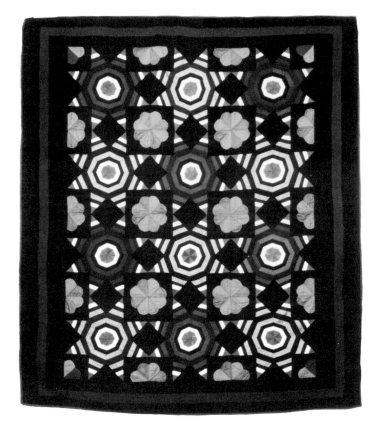

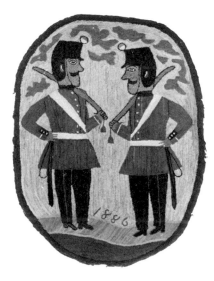

50 Hooked Rug

Rebecca Schweitzer
New Hamburg area, 1886
Wool on burlap
119 x 90 cm

49 Quilt

Anonymous
Waterloo County,
early 20th century
Pieced cotton
213 x 183 cm

Spiderwork quilts, named for the web-like pattern of the pieced sections, were produced in Old Order Mennonite communities of Waterloo County. With their intricate networks of interconnecting geometric elements, these quilts make powerful graphic statements. A particularly fine example, this vibrantly coloured quilt demonstrates its maker's thorough understanding of abstract design.

Hooked rugs of every conceivable form were produced throughout North America during the 19th century. Because designs could be worked freely on burlap backs, these rugs allowed for greater individual expression than did quilts. Consequently, a great variety of subjects were portrayed. Rebecca Schweitzer's unusual depiction of two soldiers was possibly adapted from a printed illustration.

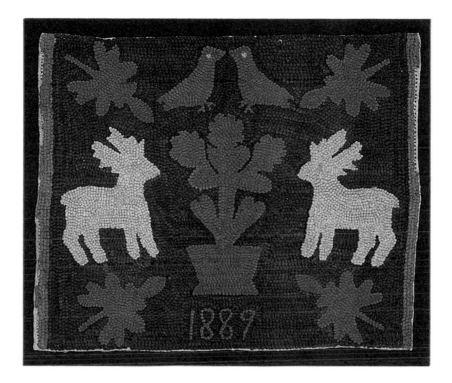

51 Hooked Rug
Anonymous
Wellesley area, 1889
Wool on burlap
66 x 79 cm

This hooked rug was made in a part
of Ontario rich in Mennonite tradi-
tions and decorative arts. The sym-
metrical arrangement of motifs
around a central, stylized flower is
reminiscent of *Fraktur*, but in a
charming departure from tradition,
the maker has included reindeer.

52 Hooked Rug
Maria Beck Warning
(1832-1918)
Brunner, 1893
Wool on burlap
64 x 120 cm

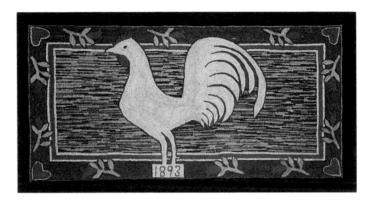

The hooked rugs of Maria Warning, an exceptionally talented artist, are imaginative portraits of pets and farm animals. Her originality and skill are evident in this life-like characterization of a bold rooster, while the stylized border is indicative of her respect for traditional folk art forms.

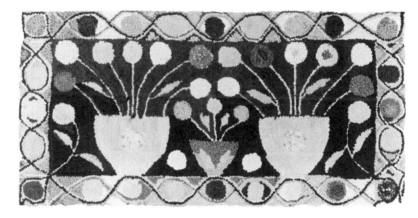

53 Hooked Rug
Anonymous
Wellesley area,
late 19th century
Wool on burlap
53 x 104 cm

This handsome rug seems to illustrate the famous axiom that nature abhors a vacuum. Flowers rise and bend from each pot to inhabit the entire field, and disembodied blooms occupy the space at the sides and bottom.

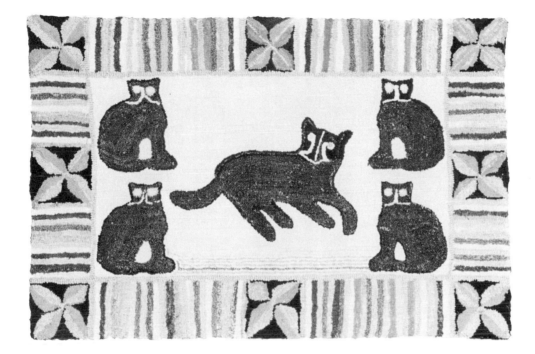

54 Hooked Rug
Anonymous
Southern Ontario,
late 19th century
Wool on burlap
104 x 153 cm

This hooked rug is a happy blend of utilitarian need and the desire for decorative embellishment. The life-like portrayal of five cats, one with outstretched paws and all with wide eyes, is a delightful illustration of the versatility of the rug-maker's art.

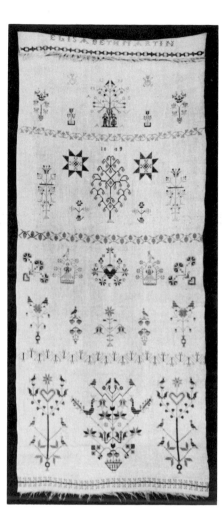

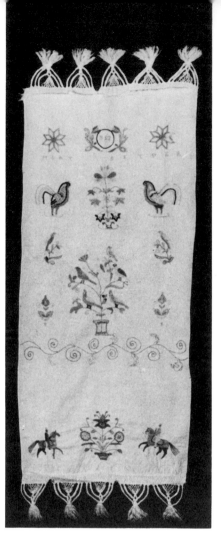

55 Show Towel
Elisabeth Martin
Waterloo County, 1849
Cotton on linen
115 x 48 cm

The most distinctive form of
Pennsylvania-German needlework in
Ontario is unquestionably the embroid-
ered show towel. Along with *Fraktur*,
show towels are probably the finest
manifestations of the Mennonite com-
munity's tendency toward decorative
expression. This exquisite specimen,
worked in a refined cross-stitch, features
a symmetrical arrangement of no less
than 27 different folk motifs.

56 Show Towel
Mary Snyder (1832-1916)
Waterloo County, 1852
Wool on cotton
130 x 50 cm

The finely wrought stitching and original
design of this show towel make it one of
the most distinctive ever produced in
Ontario. The soldier motif is very
unusual in this type of work. Note that
the riders hold no weapons – indicative,
perhaps, of an attempt by Mary Snyder to
avoid any military connotation that
would conflict with the pacifist princi-
ples of her Mennonite community.

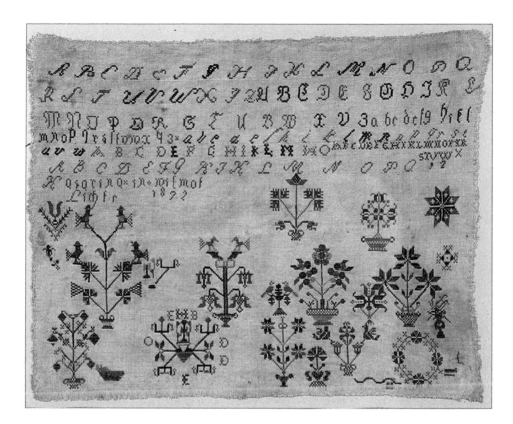

57 Sampler

Katarina Lichti
Wilmot Township, 1872
Silk on linen
38 x 47 cm

Though initially made as stitch references and pattern records, samplers eventually became measures of skill in embroidery. During the 19th century young girls in Ontario struggled to prove their ability in this traditional English art form. In 1872 Katarina Lichti produced this well executed, though somewhat unbalanced piece. Her use of stylized floral motifs and paired birds, and her omission of "J" from the alphabets reflect the influence of her Amish background.

58 Sampler
Anna Beam
Beamsville, early 19th century
Cotton on linen
43 x 21 cm

The alphabets and numerals on this small, vertical sampler are finely worked, yet the piece was abandoned. Like the trailing words of an unfinished sentence, the dangling thread leaves one with the intriguing question of what prevented the completion of this young girl's handiwork.

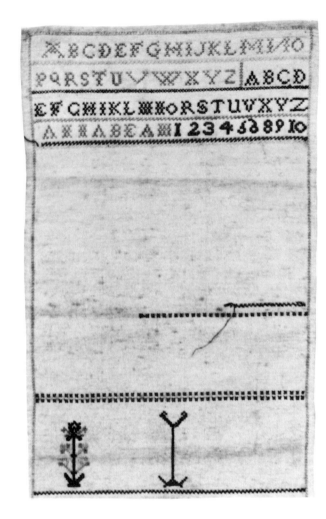

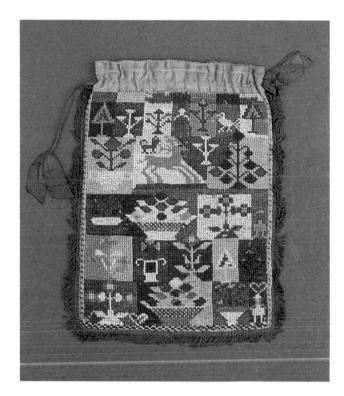

59 Handbag
Mary Burnett
Burford, 1848
Wool on linen
33 x 25 cm

In fashioning this brightly
coloured, draw-string handbag,
Mary Burnett employed the
rich needlework traditions of
her English ancestors. Both
sides of the bag are completely
worked with trees, birds,
animals and other decorative
motifs meticulously executed
in needlepoint.

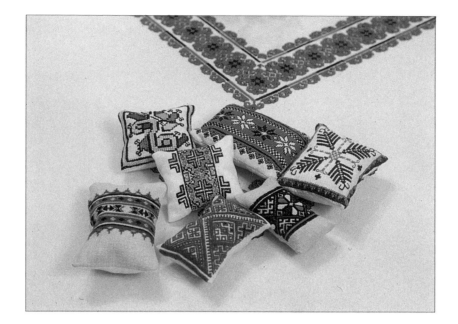

60-66
Miniature Cushions
Mrs. Walter Korol
Kitchener, 1970s
Wool on cotton canvas
Average size 6.5 x 13 cm

Traditional Ukrainian designs
have been employed in the
decoration of these miniature
cushions.

67 Grain Bag
Anonymous
Waterloo County, 1839
Unbleached tow
94 x 49 cm

During the 19th century,
farmers had to mark grain bags
to ensure their return from
grist mills. On rare occasions
they were also decorated.
This example, used by Joseph
Cressman, has several stencil-
led images.

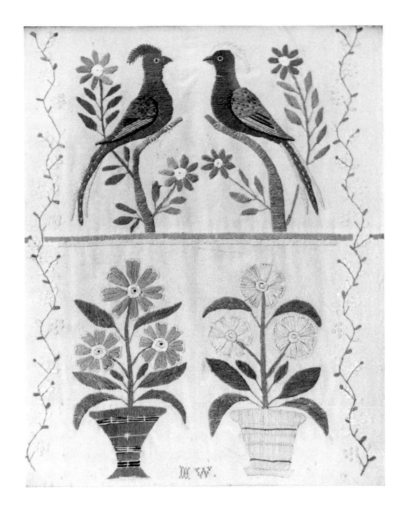

68 Embroidered Picture
Mary Webb
Niagara area, c.1830-40
Silk on silk
40 x 31 cm

Though embroidery on silk is usually
considered an English schoolgirl's art, this
picture with its symmetrically arranged
potted flowers and paired birds bears close
resemblance to *Fraktur*. Perhaps Mary Webb
drew inspiration from the decorative traditions
of her Pennsylvania-German neighbours.

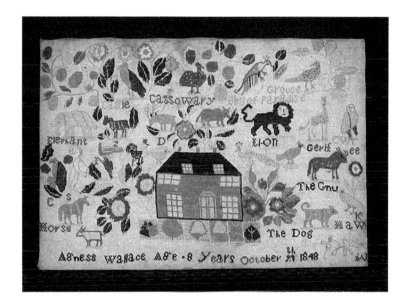

69 Sampler
 Agnes Wallace
 Eastern Ontario, 1848
 Cotton on linen
 29.5 x 40.5 cm

This work may have started out as a sampler, but the artistry and exuberance of its young maker have turned it into an embroidered picture of a most fantastic barnyard. Eight-year-old Agnes Wallace's attempt at realistic depictions of creatures ranging from "The Dog" to "Gerif" indicate a combination of technical skill and imagination rare in one so young.

CHAPTER THREE
SCULPTURE

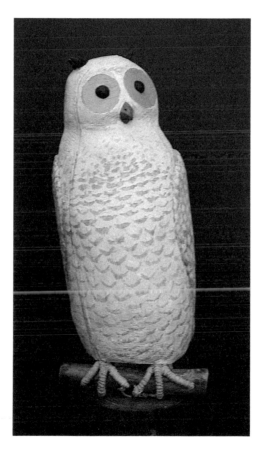

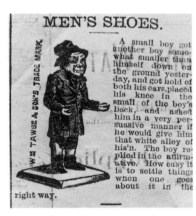

MEN'S SHOES.

A small boy got
another boy some-
what smaller than
himself down on
the ground yester-
day, and got hold of
both his ears, placed
his knee in the
small of the boy's
back, and asked
him in a very per-
suasive manner if
he would give him
that white alley of
his'n. The boy re-
plied in the affirm-
ative. How easy it
is to settle things
when one goes
about it in the
right way.

70 Store Figure
Douglas Bruce
Guelph, c.1858
Carved and painted wood
106 x 46 x 43 cm

At a time when education and
literacy were the privilege of few,
trade signs of necessity were highly
pictorial. This artfully carved
leprechaun, complete with shoes in
his outstretched hands, must have
drawn many a passerby into the
Tawse family shoe store in Guelph.
Its impish face also peered out im-
ploringly from the store's weekly ad
in *The Guelph Mercury*.

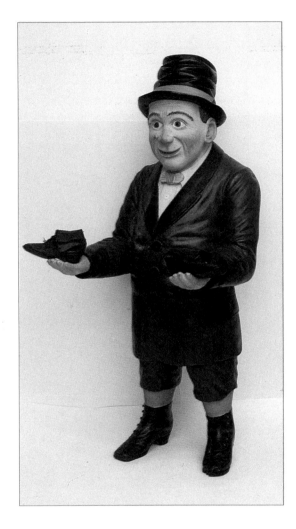

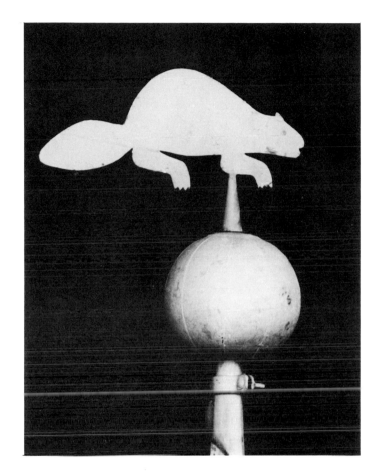

71 Weathervane
Anonymous
Bayfield, 19th century
Painted tin
71 x 18 cm, sphere
25 cm in diameter

A favourite subject for 19th-century weathervanes, the beaver proudly endorsed national pride and the virtues of industry and hard work from many Canadian rooftops. This handsome example, hand cut from sheet tin, stands astride a 3-dimensional globe constructed of deftly fitted segments.

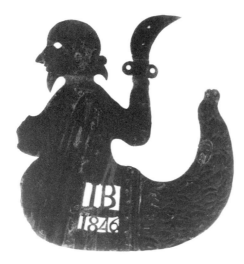

72 Weathervane

Anonymous
Thamesford, 1846
Painted tin
32 x 25 cm

Mermaid? Pirate? Sinbad the Sailor?
The specific intentions of the maker
of this truly unique weathervane are
not apparent; nor is the identity
of "I.B." No doubt this enigmatic
figure provoked as much spirited dis-
cussion in the 19th century as it
does today.

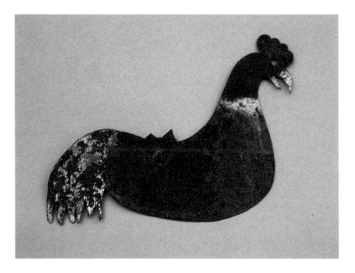

73 Weathervane

Anonymous
Southwestern Ontario,
late 19th century
Painted tin
38 x 30 cm

The rooster, long a symbol of watch-
fulness, is associated in Christian
tradition with Peter's denial of
Christ. To remind the faithful of this
betrayal, it is frequently placed atop
church steeples. In rural settings
weathercocks play a more mundane
role, extolling the virtues of early
rising and adding a proud decorative
touch to farm buildings.

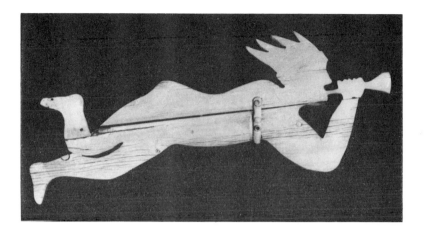

74 Weathervane

Justus Dierlamm
Neustadt, early 20th century
Painted wood
43 x 108 cm

Many weathervanes made in
Ontario embody classical or
popular forms interpreted in
a truly individual manner.
Justus Dierlamm, an eclectic
and highly inventive artist,
has combined two unlikely
figures here – an Indian Chief
and the Angel Gabriel – into
one marvelous character
sporting a headdress and
blowing a trumpet.

75 Whirligig

Justus Dierlamm
Neustadt, early
20th century
Carved and
painted wood
93 x 75 cm

Whirligigs, or wind toys, were
introduced into North Amer-
ica by European carvers in the
19th century. They have never
had a set subject matter – any-
thing from the practical to the
absurd is acceptable. Justus
Dierlamm was among many
who enjoyed experimenting
with the form. This whimsical
piece, a combination whirligig
and weathervane, crowned his
workshop roof for many years.

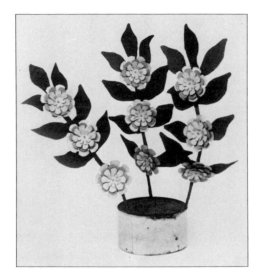

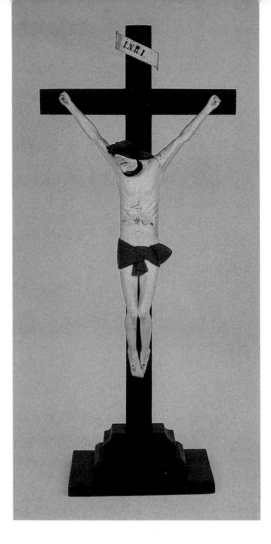

76 Pot of Flowers

Albert Geisel (1889-1972)
Elmira, c.1950
Painted tin
59 x 55 cm

Following his retirement in the late
1940s, Albert Geisel amused himself
and his neighbours by decorating vir-
tually every nook and cranny of his
small home in Elmira. Often using
discarded bits of wood, plastic, glass
and old machine parts, he turned out
many eye-catching works. Here he
has ingeniously pieced together tiny
cut-outs of tin to create a cheerful,
ever-blooming pot of flowers.

77 Crucifix

Anonymous
Gasline, 19th century
Carved and painted wood
84 x 34 cm

The simplicity of line in the delicately
shaped figure on this carving reveals
the work of a spirited amateur crafts-
man. The crucifix stood for many
years in the sanctuary of St. John's
Lutheran Church in the Welland
County community of Gasline.

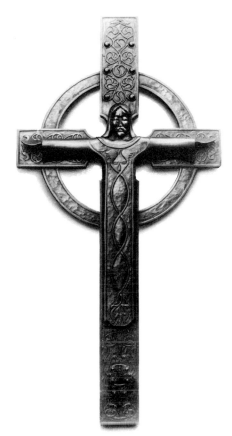

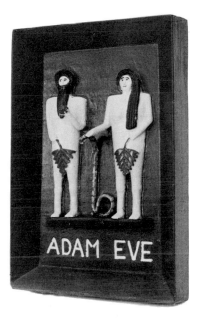

78 Crucifix
Robert Wylie
Thomasburg, 1982
Carved and painted wood
150 x 75 cm

Liturgical motifs on this cruci-
fix reflect the Celtic back-
ground of its maker, Robert
Wylie. In a traditional depic-
tion of the triumph of life over
death, the figure of Christ is
shown fully clothed.

79 Adam and Eve
J. Seton Tompkins (b.1899)
Singhampton, c.1980
Carved and painted wood
35 x 23 cm

J. Seton Tompkins' propensity
for storytelling is evident in his
choosing to carve this familiar
Biblical scene. The simple
lines and spare detail enhance
the commanding effect of the
two figures. An element of
theatricality is imparted by the
serpent, who appears to be
taking a final bow.

80-86
Farm Animals
David B. Horst
(1873-1965)
Waterloo County,
c.1935-1943
Carved and
painted wood
Average size 10 x 14 x 3 cm

It is sometimes only in later life or in the wake of tragic circumstances that folk artists discover their creative abilities. Such was the case with David Horst who became especially productive after suffering a crippling stroke. The delightful animals he carved are rendered with great skill and affection, and often decorated in the Pennsylvania-German tradition of red and green stippling.

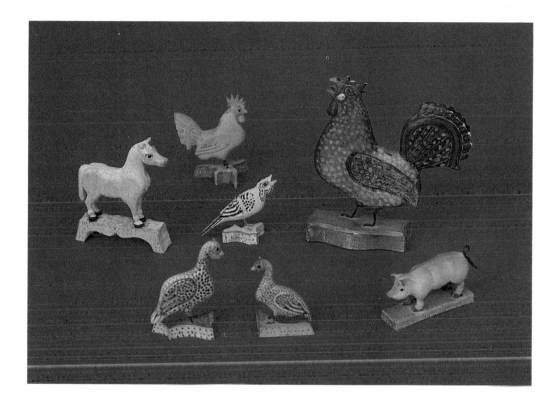

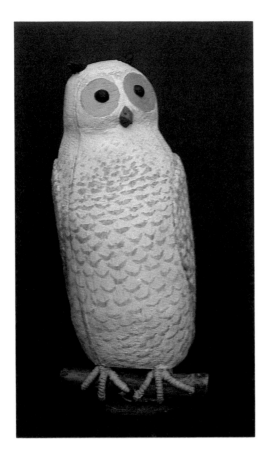

87 Owl
J. Albert Hoto
Stromness, c.1950
Carved and painted wood
79 x 25 cm

Albert Hoto, a German immigrant, retired
from farming in the early 1950s, took up
woodworking as a pastime, and eventually
hung out a sign proclaiming himself an orna-
mental carver. He fashioned innumerable
pieces, some lifesize. The pleasure and delight
he found in his carving is evident in this
simple, wide-eyed owl.

88 Owl
Anonymous
Cottam, second half of the 19th century
Carved and painted wood, glass eyes
42 x 14 x 9 cm

This charming figure with eyes in both front
and back undoubtedly deterred many birds
from alighting in the Essex County garden in
which it served as a scarecrow.

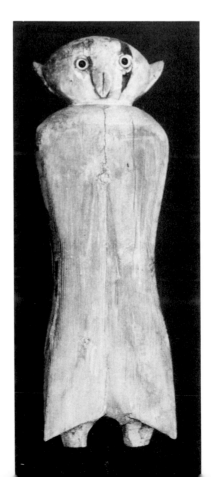

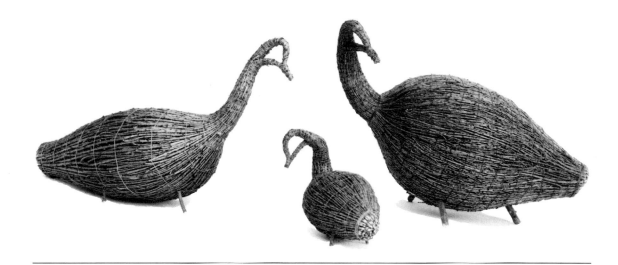

89-91
Tamarack Birds
Anonymous
James Bay area, c 1960
Tamarack twigs
28 x 45 x 18 cm
15 x 16 x 11 cm
30 x 45.5 x 24 cm

Although it is only in recent years that tamarack birds have begun to appear on the shelves of Ontario's gift shops, they have been made by Cree Indians since the late 19th century. The modern birds are smaller than the original hunting decoys, but the same bulbous bodies, slender necks and turned heads characterize this eye-catching art form.

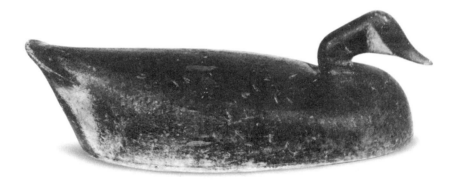

92 Decoy

George Warin (1830-1904)
Toronto, c.1865
Carved and painted wood, glass eyes
23 x 68 x 30 cm

Carved decoys are a uniquely North American folk art form adapted from the traditional skin-and-feather hunting lures made by Natives. One of the earliest carvers in Ontario was George Warin, whose remarkable sensitivity for form and balance is evident in this Canada Goose. Enduring as both art object and sportsman's aid, this decoy was used for hunting as recently as 1980.

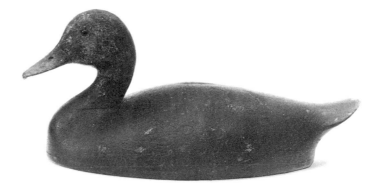

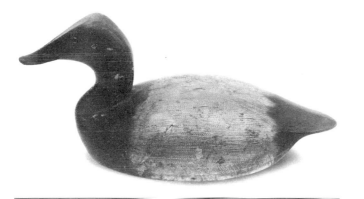

93 Decoy

Tom Chambers (1860-1948)
St. Clair Flats, c.1915
Carved and painted wood,
glass eyes
16 x 42 x 19 cm

A highly valued, much sought-
after species, the canvasback was a
favourite subject of decoy carvers
and was considered by some to be
their crowning achievement. This
handsome drake was carved by
Tom Chambers, marsh manager of
the St. Clair Flats Shooting Club
from 1900 to 1943. The fine comb-
painting on the body and the
detailed rendering of the bill are evi-
dence of his expert craftsmanship.

94 Decoy

Ivar Gustav Fernlund
(1881-1933)
Hamilton, c.1915
Carved and painted wood,
glass eyes
17 x 35 x 17 cm

Both duck hunter and skilled
craftsman, Ivar Fernlund was
painstaking in his efforts to
create life-like decoys. The
fluid form and fine proportions
of this graceful blackduck and
the meticulously scratch-
painted feathers of its blended
plumage attest to his remark-
ably refined style.

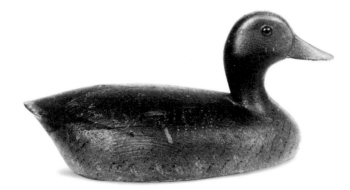

95 Decoy
 Charles P. Reeves
 (1872-1941)
 Port Rowan, c.1920
 Carved and painted wood,
 glass eyes
 12.5 x 25 x 14 cm

 This beautifully carved and
 painted drake is a rare work
 since the tiny Green Wing
 Teal has seldom been depicted
 in decoy form. It was made by
 Charles Reeves, one of three
 generations of Reeves, begin-
 ning with his father Phineas,
 who carved decoys for a
 famous duck-hunting club,
 the Long Point Company.

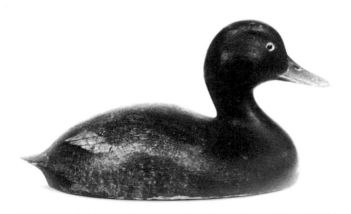

96 Decoy
 Jack Morris
 Hamilton, c.1920
 Carved and painted wood,
 glass eyes
 15 x 28 x 15 cm

 Jack Morris was a boatbuilder who
 brought his diverse skills to decoy
 carving. The superior quality of his
 work extends to all phases of con-
 struction: careful selection of the
 wood, precise carving of the profile,
 and sensitive painting of the fea-
 tures. This chunky scaup with its
 short, stubby tail is a particularly
 fine example of his work.

78

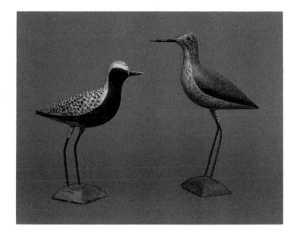

98-99
Shorebird Decoys
Anonymous
Toronto, c.1880
Carved and painted
wood, wire
29 x 28 x 7 cm
35 x 32 x 7 cm

Very few shorebird decoys exist
today, probably because hunt-
ing of these birds has been
banned in Canada and the
United States since 1916.
These two examples, a Black-
bellied Plover and a Yellow
Legs, have been rendered in
characteristically pert and life-
like stances by an expert arti-
san. Miraculously, they have
survived with their fragile bills
intact.

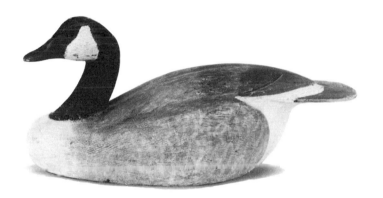

97 Decoy
Ken Anger (1905-1961)
Dunnville, c.1948
Carved and painted wood,
glass eyes
28 x 60 x 24 cm

At times Ken Anger has been
referred to as the "Rasp Master"
because of his skill in texturing the
surface of decoys with a carpenter's
tool. This enormous, hollow-bodied
Canada Goose is a fine example of
the technique. A beautifully turned
head and an elongated tail heighten
the overall impact of this splendid
piece.

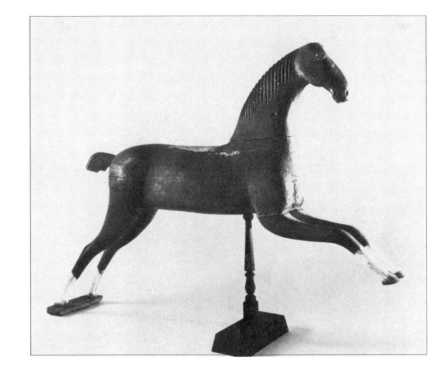

100 Carousel Horse
 John Gemeinhardt (1826-1912)
 Bayfield, late 19th century
 Carved and painted wood
 115 x 153 x 23 cm

101 Sketchbook
 John Gemeinhardt (1826-1912)
 Bayfield, late 19th century
 Ink on paper
 15 x 9.5 cm

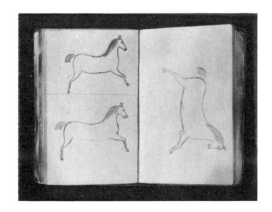

When he immigrated to Upper Canada from
Bavaria in the mid-1850s, John Gemeinhardt
brought with him several trunks filled with wood-
working tools. He settled in Bayfield and served
that community in various capacities – car-
penter, undertaker, cooper and cabinet-maker –
for the rest of his life. At the request of one client,
he designed and carved a set of six carousel
horses. All that remains today are some sketch-
book drawings and this one specimen, a striking
sculptural work with strong profile, deeply articu-
lated mane, and expressive face.

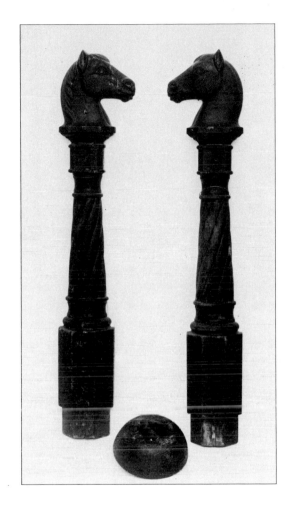

102 Mould
Anonymous
Guelph, c.1870
Carved and painted wood
100 x 14.5 cm

Cast-iron objects cannot
easily be defined as folk art,
but the moulds used in their
manufacture are another mat-
ter. The detailed carving of
the horse's head on this hard-
wood hitching-post mould
could only have been done by
a master craftsman.

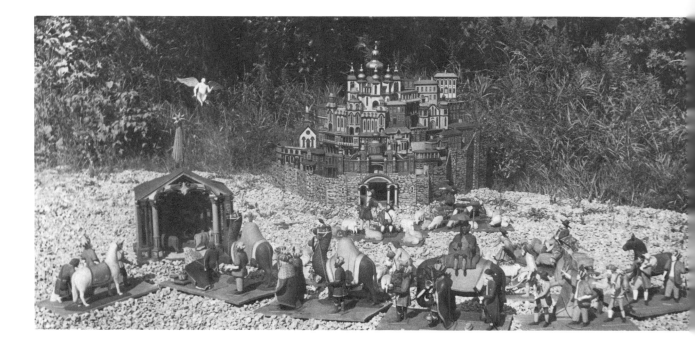

103-119
Crèche
Karl Schoen (1832-1890)
Clifford, 1880s
Carved and painted wood
Overall assembled size
2.75 x 3.5 m
Doon Pioneer Village,
Kitchener

During his youth in Austria, Karl Schoen was undoubtedly exposed to and inspired by the country's rich wood-carving tradition. Years after his immigration to Ontario he decided to undertake a monumental project: the creation of this complex nativity scene. For seven years he aged the wood, and for the next six he devoted himself to carving. Though there are approximately 150 figures in the work, Schoen apparently had not finished the project when he died. According to his granddaughter he intended to add several more pieces. This crèche is a work of bold imagination and design; the many-tiered village of Bethlehem with its eclectic mixture of Moorish, Austrian-Baroque and Ontario-Gothic architectural elements is testament alone to Schoen's genius.

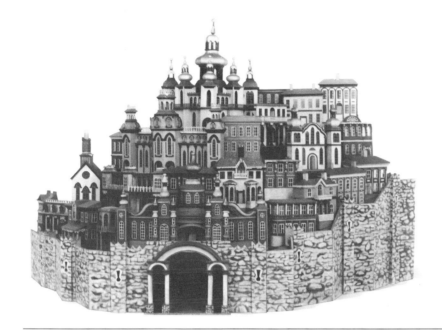

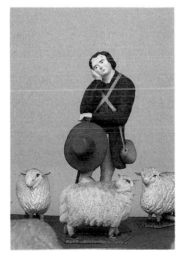

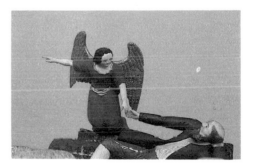

83

CHAPTER FOUR
UTILITARIAN OBJECTS

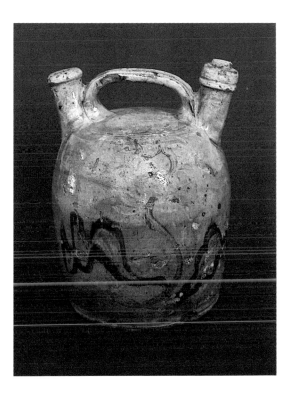

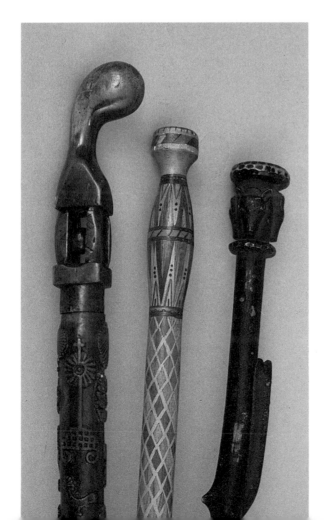

120-122
Walking Sticks
Anonymous
Southern Ontario,
19th century
Carved, stained,
inlaid and painted wood
99 x 5.5 cm
93 x 5.5 cm
84 x 4 cm

A favourite product of the whittler,
walking sticks lend themselves to a
wide variety of decorative motifs.
Several ethnocultural traditions are
reflected in the details of these exam-
ples. The geometric elements of the
inlaid cane from Waterloo County
recall decorative techniques used on
Pennsylvania-German furniture.
The deftly carved animal heads and
entwining snake on the second stick
suggest that it was inspired by Indian
decorative arts. The long cane,
found in a French community near
Lake St. Clair, is profusely engraved
with figurative and symbolic motifs
that are similar to those used on
prototypes in Quebec.

123 Club

Anonymous
Six Nations Reserve, 19th century
Carved wood
34 x 14.5 cm

Craftsmen from the Six Nations
Reserve near Brantford have
received considerable acclaim for
the quality of their artistic
endeavours. This club, worked in
burled hardwood, is distinguished by
the sensitive carving of a well-
articulated face within a cupped
hand.

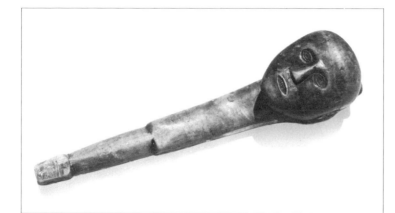

124 Mallet

Anonymous
Six Nations Reserve, 19th century
Carved wood
40 x 24 cm

The head of this mallet,
carved perhaps for ceremonial
purposes, contains a ball-in-
case, one of the most popular
tests of the whittler's skill. The
hand, carved in low-relief, is a
motif that occurs with some
regularity in the decorative
arts of Ontario's native wood-
land peoples.

125-127
Ladles
Anonymous
Six Nations Reserve,
19th century
Carved wood
15 x 7 cm
15.5 x 9 cm
28 x 11 cm

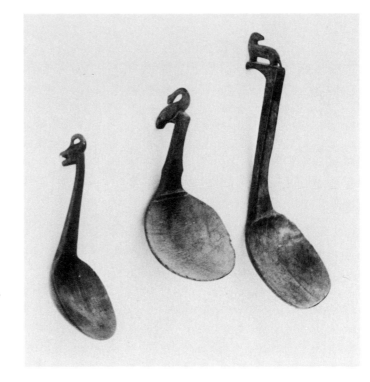

Decorated tools and utensils often
appear to be personal expressions
even though nothing is known about
the individual who fashioned them.
The finely carved duck, swan and
otter at the tips of these ladles indi-
cate their maker's wholehearted
adherence to the rich woodcarving
tradition of the Six Nations Reserve.

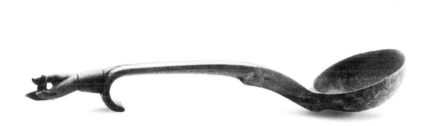

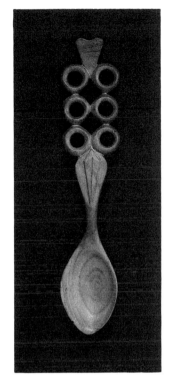

128 Ladle

Anonymous
Eastern Ontario,
19th century
Carved and
stained wood
36 x 11 cm

The hand motif, used repeat-
edly in Ontario folk art, is
rendered here with marvelous
innovation. The delicately
carved, curved and pointing
fingers add a truly unusual em-
bellishment to an everyday
kitchen utensil.

129 Spoon

Anonymous
Elora, 19th century
Carved wood
20.5 x 4 cm

It is customary among many ethno-
cultural groups to present fancy
spoons on ceremonial occasions
such as baptisms and weddings.
Often these spoons are carved in
imitation of more costly silver
pieces. Such is the case with this
finely shaped hardwood spoon. It
closely resembles ancient Welsh
betrothal spoons, suggesting that
it was crafted by a member of the
Welsh community.

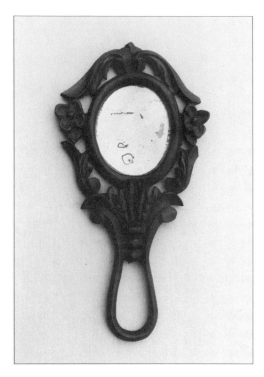

130 Mirror Frame

Anonymous
Wilno area, 19th century
Carved wood
22 x 12 cm

Polish settlers in the Wilno
area of Renfrew County were
quite isolated from the rest of
the province. Their folk art
traditions tended, as a result,
to survive unaltered longer
than did those of other ethno-
cultural groups. This beauti-
fully carved mirror frame,
richly embellished with floral
motifs, is a fine example of the
vitality of that decorative
tradition.

131 Wedding Cake

Anonymous
Toronto, 1983
Varnished bread dough
12.5 x 23 cm

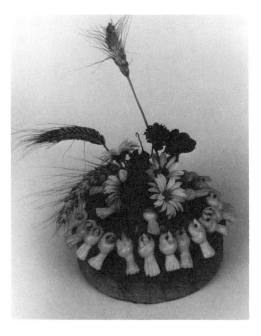

Not always intended for human
consumption, decorated breads and
cakes are a folk art form associated
with celebration and ceremony. This
wedding cake, or *Korovai*, is a visual-
ly delicious example of the art as
practised in the Ontario Ukrainian
community. It has been profusely
decorated with tiny birds, symbols of
love, and crowned with wheat and
flowers, symbols of fertility and
long life.

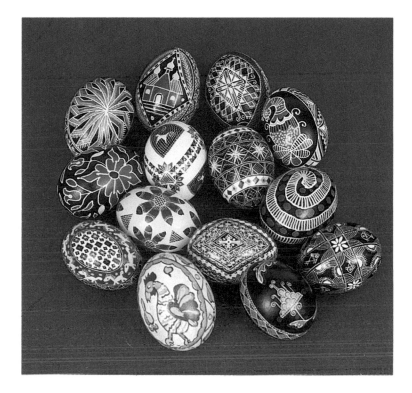

132-144
Chicken Eggs
Natalie Korol
Kitchener, 1970s-1980s
Painted eggs
Average size 7.5 x 5 cm

148-150
Butterprints
Anonymous
Southern Ontario,
19th century
Carved wood
14.5 x 4.5 cm
6 x 6 cm
13 x 6.5 cm

Pressing a design onto butter for special occasions and honoured guests was a common practice in many 19th-century households. Prior to the manufacture of commercial moulds, butterprints were carved in a wide range of decorative forms. The tulips and bird shown here suggest Pennsylvania-German influence, while the shield-like decoration is reminiscent of American design motifs.

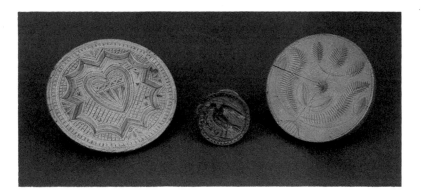

145-147
Goose Eggs
Natalie Korol
Kitchener, early 1980s
Painted eggs
Average size 15 x 7.5 cm

One of the most familiar of Ukrainian folk art customs is the decoration of Easter eggs. This practice has come to be known as *psyanky*, a form of the Ukrainian word "to write," in reference to the spiritual greetings sometimes inscribed on the eggs. The various designs on these goose eggs and on the chicken eggs shown on the previous page reflect the diversity of decorative techniques used in the Ukraine.

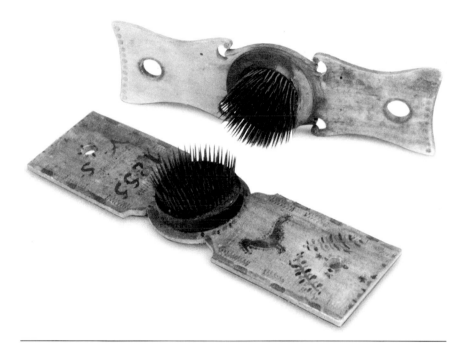

151-152
Heckles
Anonymous
Southwestern Ontario,
19th century
Painted wood
16.5 x 59 cm
15 x 59 cm
*Joseph Schneider Haus,
Kitchener and
Private Collection*

A comb used for breaking down flax fibres prior to spinning and weaving into cloth, the heckle consists of a round cluster of spikes mounted in a slightly scrolled or shaped backboard. Though the most mundane of tools, the heckle was often decorated. The painted circles, geometric patterns and bird motif exhibited on samples here reflect traditional Pennsylvania-German design tastes.

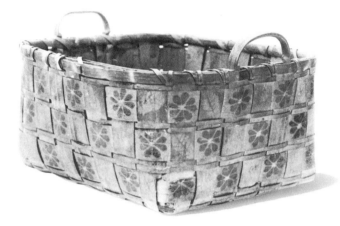

153-155
Baskets
Anonymous
Six Nations Reserve,
19th century
Ash splint
15.5 x 34 x 10 cm
38 x 48 x 36 cm
24 x 38 x 30 cm

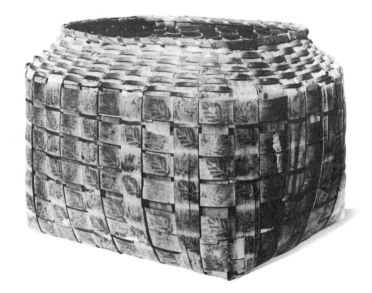

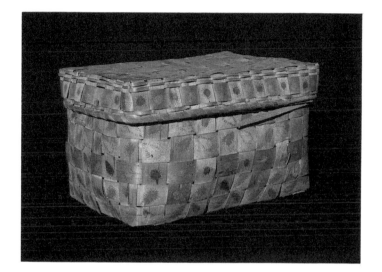

Out of practical need, North
American Indians crafted a
variety of natural fibre baskets.
They often used ash because it
is a pliable wood from which
splints can easily be prepared,
and strong, durable containers
woven. Unlike coiled grass,
which can be worked in
coloured patterns, ash splint
does not lend itself to decora-
tive weaving; and so the
makers of these handsome
baskets have used a relief-print
technique to embellish them.

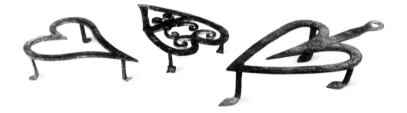

156-158
Trivets
Anonymous
Southern Ontario,
19th century
Forged iron
3.5 x 15 x 10 cm
4 x 15 x 11 cm
4.5 x 24 x 12 cm

Although decorated cast-iron trivets
are so common that they are not
usually thought of as folk art, earlier
hand-forged examples clearly
demonstrate individual artistry. A
strong sculptural quality and a strik-
ing clarity of design characterize
these three trivets from Rockwood,
Waterloo County and Grey County.
They illustrate interesting variants
of the Pennsylvania-German heart
motif: scrolled, wide and elongated.

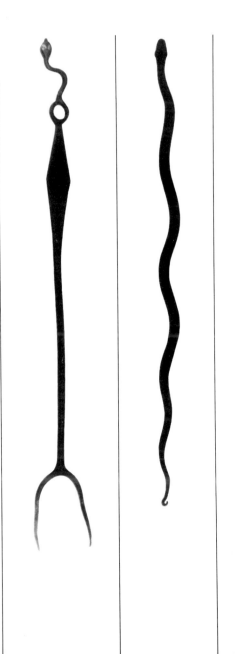

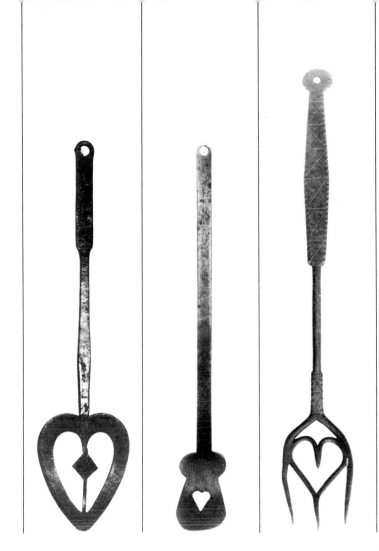

159-163
Utensils
Anonymous
Ontario, 19th century
Forged iron
50 x 5 cm
47.5 x 2 cm
46.5 x 11 cm
16 x 4 cm
24 x 4 cm
Doom Pioneer Village,
Kitchener and
Private Collections

On occasion kitchen utensils received decorative treatment. The popular heart motif was used to embellish several items shown here – peel, spatula and fork from Waterloo, Haldimand and Lanark Counties, respectively. Snake designs seem to have been a favourite as well, as evidenced by the fork with snake handle signed "P. LaPointe," an Alsatian name common in Welland County where it was found, and by the apparently functionless snake form – an anonymous blacksmith's attempt at art for its own sake.

165 Pencil Box

John McDougall
Conn, 19th century
Carved wood with
lead inlay
3.5 x 26 cm

This carved and inlaid pencil
box, made by John McDougall,
a Scottish immigrant, is a
"sampler" of decorative tech-
niques with its whittled
handle, rows of chip-carved
designs and inlaid lead heart.

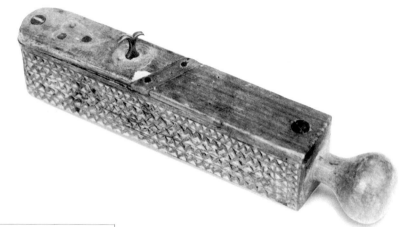

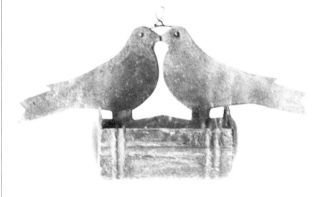

164 Match-holder

Anonymous
Waterloo County, 19th century
Painted tin
12 x 20.5 cm

Considerable skill and artistry have
gone into the making of this match-
holder. Shaped, pounded, rolled and
soldered metal was used in the tray
and a finely cut shape was used for
the top. The paired birds bring to
mind the symmetrical, Pennsyl-
vania-German designs found on
Mennonite needlework and *Fraktur*.

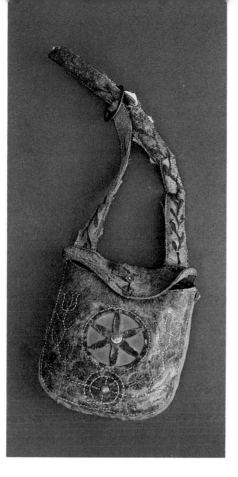

168 Pouch

Anonymous
Waterloo County, 1836
Cut leather
20 x 16 cm

Richly decorated with designs cut and sewn into the leather, this hunter's pouch is an outstanding expression of Pennsylvania-German folk art. Of particular note is the six-sided compass star flanked by undulating tulips.

166-167
Powder Horns

Anonymous
Chesley, 19th century
Incised horn
6 x 22 cm
5 x 15 cm

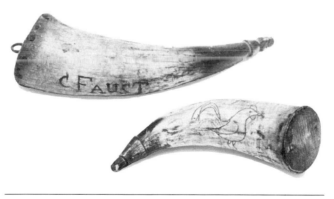

Scrimshaw – decorative carving in horn, ivory, shell or bone – provided folk artists with a means of personalizing utilitarian objects. These powder horns, found in an area of Continental-German settlement in Bruce County, are an excellent example. One features an incised picture of a chicken; the other, the name of the initial owner, C. Faust.

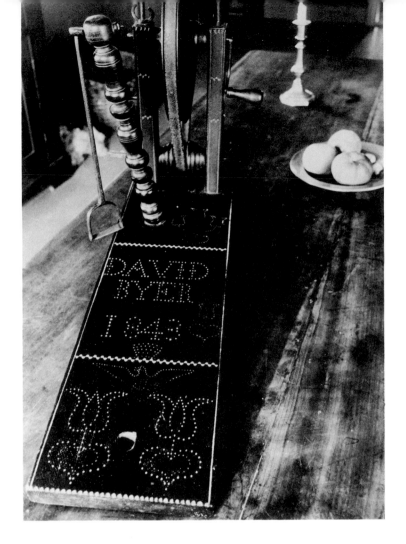

169 Apple Peeler
David Byer
Markham, 1843
Painted wood
49 x 73 x 19.5 cm
*Black Creek
Pioneer Village,
Toronto*

This apple peeler effectively
counters the notion that
domestic utensils do not lend
themselves to the decorative
impulse. During the 19th cen-
tury, punchwork designs were
commonly applied to tin sur-
faces, but seldom to wooden
objects. The peeler, with its
lavish embellishment of birds,
hearts and flowers, is the work
of a truly inventive craftsman.

171 Jug
Anonymous
Niagara area,
19th century
Glazed
earthenware
28 x 23 cm

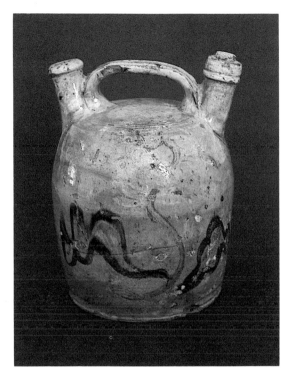

This two-spouted earthenware jug,
found in the lower Grand River
Valley near Dunnville, combines
qualities of durability and practical-
ity with the beauty of a simple form.
The floral design reminiscent of
Pennsylvania-German motifs adds
to its aesthetic appeal.

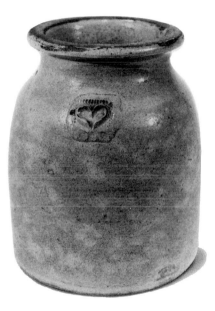

170 Storage Jar
Joseph Wagner
Berlin (Kitchener), late 19th century
Glazed earthenware
18 x 15 cm

Before English ceramics became popular and accessi-
ble, many local potteries flourished in this province.
The commonplace articles they produced were often
given only a simple glaze with little concern for artistic
effect, but a substantial body of Ontario-German
earthenware is distinguished by mottled, drawn or
incised decoration. For example, this functional jar,
made by Joseph Wagner, is embossed with a heart.

173-174
Sugar Bowls
Anonymous
Ontario, 19th century
Glazed earthenware
19 x 13.5 cm
15 x 13 cm

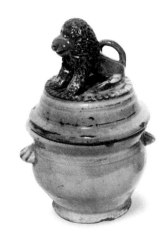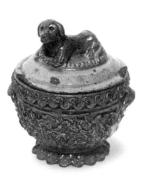

The lion and dog on the lids of these earthenware bowls are so well-sculptured that considerable personality is suggested in their expressive features. Probably the work of a single artisan, these bowls are indeed among the finest of folk whimsies.

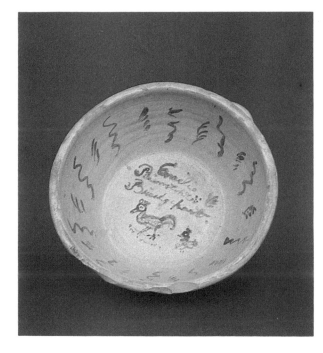

172 Bowl
Adam Biernstihl (1825-1899)
Bridgeport, late 19th century
Glazed earthenware
15 x 36 cm

With the addition of a whimsical depiction of two birds, Adam Biernstihl has transformed a commonplace earthenware bowl into an expressive piece of folk art. An Alsatian immigrant who established a pottery in Waterloo County, he was perhaps freer in his decoration of this bowl than with his other pieces since it was made for his daughter Emilie.

102

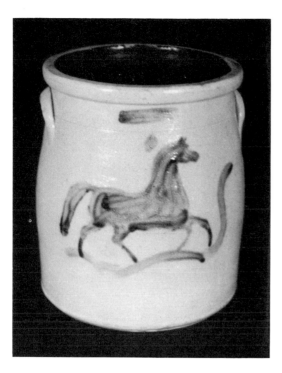

175 Crock

David Flack and
Isaac Van Arsdale
Cornwall, 19th century
Glazed stoneware
35.5 x 28 cm

Decorated stoneware was popular in the
northeastern United States throughout the
19th century and was introduced into Ontario
by American immigrants. Typically these
wares were embellished with cobalt blue floral
motifs quickly applied with stick, brush or
finger. The beautifully drawn, prancing horse
on this crock is highly unusual.

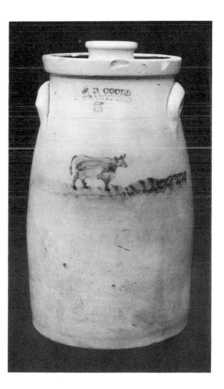

176 Churn

Franklin P. Goold
Brantford, c.1859-1867
Glazed stoneware
46 x 25 cm

An entrepreneur originally from New
Hampshire, Franklin Goold gained wide
recognition after winning first prize for the
best assortment of stoneware in the Ontario
Provincial Exhibition of 1860. His diverse
skills became legendary and, judging from this
churn with cow motif, his reputation was
well-deserved.

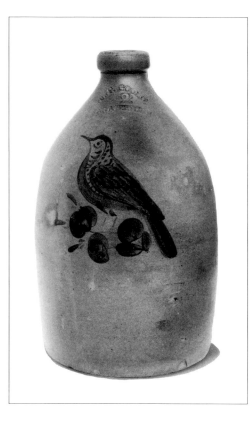

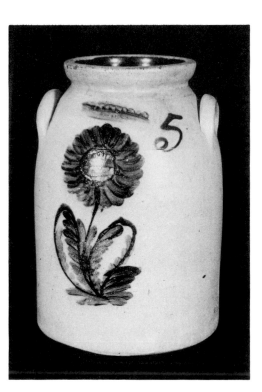

177 Jug
Franklin P. Goold
Brantford, c.1859-1867
Glazed stoneware
37 x 21.5 cm

This two-gallon stoneware jug
crafted by Franklin Goold had ready
application for the storage of
molasses, vinegar or spirits. With
the addition of a charming little
robin it also became a vehicle for
self-expression.

178 Storage Jar
Nicholas Eberhardt
Toronto, c.1865-1879
Glazed stoneware
42.5 x 28 cm

French-born potter Nicholas
Eberhardt produced decorated
stoneware, such as this jar with
sunflower, that had a distinctive,
Alsatian flavour.

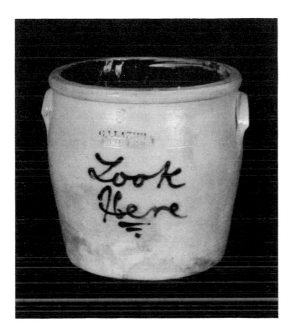

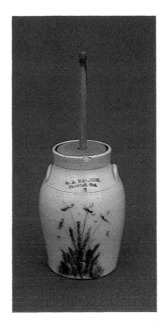

180 Miniature Churn
William E. Welding
Brantford, c.1873-1894
Glazed stoneware
9.5 x 7 cm

Made as a salesman's sample or
as a specialty piece, this stone-
ware miniature illustrates a re-
markable refinement of detail.

179 Crock
George I. Lazier
Picton, c.1864-1879
Glazed stoneware
27 x 29.5 cm

Stoneware is a very unlikely medium
for the expression of humour, but at
least one Ontario potter, George
Lazier, did not hesitate to decorate
his wares with comical inscriptions
ranging from the tongue-in-cheek
salutation, "Martha Dear" to the
irresistible invitation, "Look Here."

CHAPTER FIVE
GAMESBOARDS

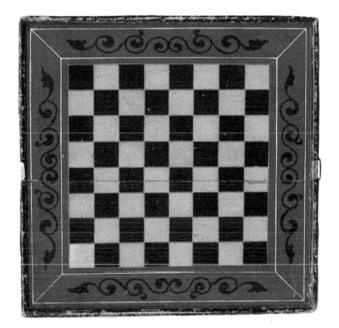

181 Chequerboard

Anonymous
Port Dover,
19th century
Painted wood
55 x 38 cm

Many of the innumerable
gamesboards that were hand-
crafted in the 19th century
were lavishly decorated. The
maritime scenes depicted at
each end of this board's play-
ing surface probably show the
lighthouse and shoreline at
Port Dover where it was found.

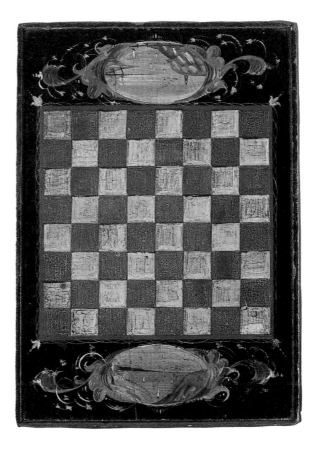

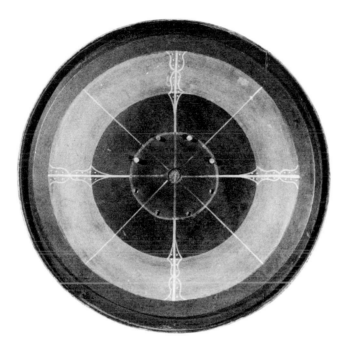

182 Crokinole Board
Eckhardt Wettlaufer
(1845-1919)
Sebastopol, 1875
Painted wood
66 cm in diameter

Among the finest folk objects
created by Eckhardt Wettlaufer, a
Perth County painter and wagon-
maker, is this crokinole board
made for his five-year-old son,
Adam. Its stylized tulips recall the
stencilled designs he applied to
his sleighs and wagons.

184 Chequerboard
Anonymous
Delhi, 19th century
Painted wood
53 x 53 cm

The bold, skilfully executed
flourishes that border this
chequerboard are reminiscent
of stencilling done on
Continental-German furni-
ture in the late 19th century.

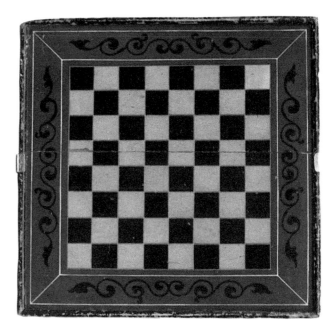

183 Chequerboard
Anonymous
Middlesex County,
19th century
Painted wood
39 x 39 cm

The juxtaposition of dark red
and ochre squares makes this
gamesboard particularly strik-
ing. Its most interesting decor-
ative feature is the border
which has been carefully
painted to create the illusion
of a brass rail enclosing the
board.

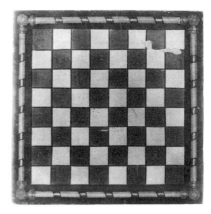

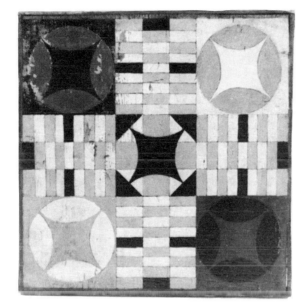

185-186
Parcheesi Board
with Token Box
Anonymous
Ancaster, 19th century
Painted wood
40 x 39 cm
4 x 17 x 8 cm

Although most handcrafted gamesboards were intended for domestic use, this one may have been fashioned for a different purpose. The token box that accompanies it is labelled "club checkers" as well as "checker men," suggesting that its maker belonged to a leisure-time organization.

CHAPTER SIX
FURNITURE & ACCESSORIES

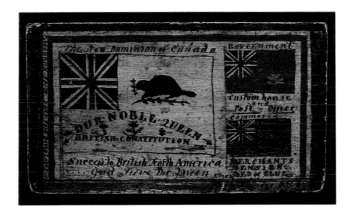

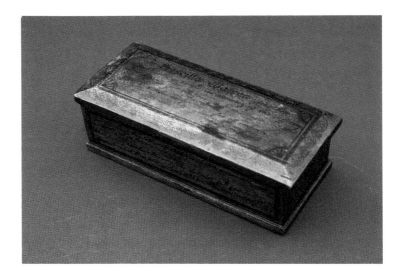

187 Box

Josephus Watson
Toronto, 1837
Ink on wood
5 x 15.5 x 6.5 cm

Following the abortive Rebellion of 1837, many of its supporters were imprisoned. Some carved mementoes or tributes in the form of "coffin boxes," so-called because of their shapes and because they were fashioned by men who fully expected to be hung for treason. On this intriguing example, Josephus Watson has inscribed a dedication to his wife and consoling Biblical texts.

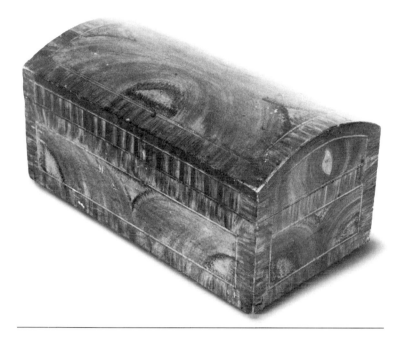

188 Box
Anonymous
Norfolk County,
early 19th century
Painted wood
15 x 31 x 16 cm

The flamboyant "rainbow"
decoration of this dome-
topped box has strong parallels
with designs on painted furni-
ture in New England, suggest-
ing that its maker was
American in background.

190 Wallbox
Anonymous
Perth County, mid-19th
century
Painted wood
22.5 x 32.5 x 15 cm

Furniture and accessories from Perth
and Waterloo Counties suggest the
intermingling of design ideas from
the region's German and Scottish
communities. The form of this wall-
box is, for example, associated with
Scottish prototypes, while its floral
decoration derives from German
folk traditions.

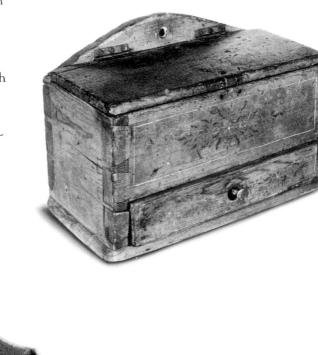

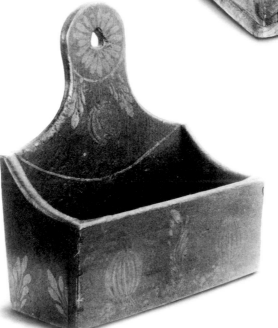

189 Candle Box
Anonymous
Lindsay, mid-19th century
Painted wood
34 x 28 x 13 cm

The stencil-like work on this
attractive candle box recalls
painted room interiors and
furniture decoration in the
northeastern United States.

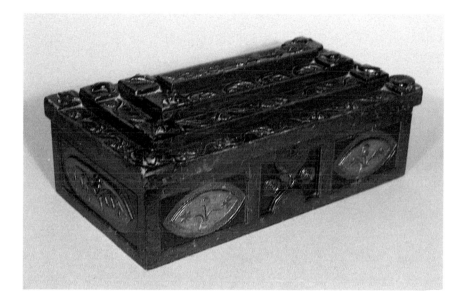

191 Box
Anonymous
Markham area, mid-19th
century
Carved and painted wood
19 x 47 x 25.5 cm

Few boxes are as sumptuously carved as this one. In building up the lid and sides in tiers, its maker has been able to create individual bands and panels of floral ornamentation. An exceptional piece, the box owes its design more to the exuberance of its maker than to the traditions of any ethnocultural group.

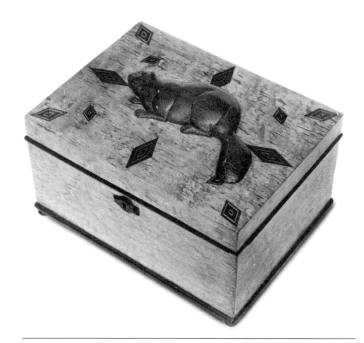

192 Box
Anonymous
Kingston, mid-19th
century
Carved wood
15.5 x 28 x 21 cm

Although this box is
rather formal in its re-
fined construction, the
inlaid lozenges and
beaver on its lid add a
more personal touch.

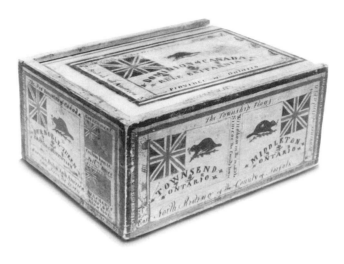

193 Box
　Alexander McNeilledge
　(1791-1874)
　Port Dover, 1867
　Painted wood
　12.5 x 28.5 x 22 cm

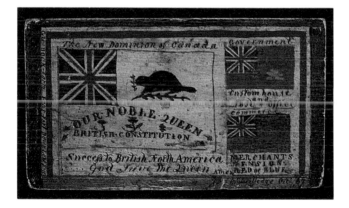

Canada's Confederation was marked by pageantry, musical events and literary tributes. But was it celebrated in folk art? In one case, at least, the answer is a resounding "Yes!" Alexander McNeilledge expressed his patriotic sentiments in the creation of this spirited memorial, a candle box profusely decorated with flags and beavers. The profundity of the occasion did not deter McNeilledge from summing up his handiwork with the wry comment, "Pretty fair for an auld Scotchee in his 75th year."

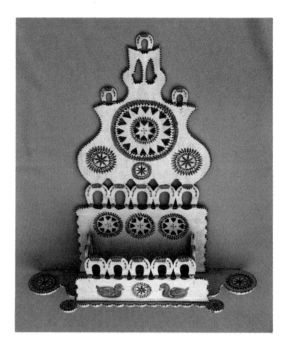

194 Wallbox
Fred G. Hoffman (1845-1926)
Tavistock, 1921
Carved and painted wood
47 x 43 x 13 cm

No ordinary transient, Fred Hoffman possessed a personality so magnetic that he was welcomed as a house guest in many Mennonite and Amish homes. As tokens of appreciation to his hosts, he made elaborately carved and painted wallboxes. This example incorporates a mixture of traditional Pennsylvania-German folk motifs with more modern, eclectic elements drawn from Hoffman's own itinerant life.

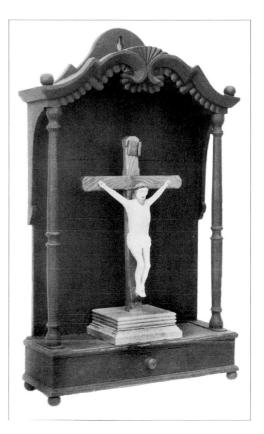

195 Shrine

Anonymous
Wilno area, second half
of the 19th century
Carved and painted wood
95 x 47 x 16 cm

The great value attached to this household
shrine is evident in the care with which it
has been fashioned. Similar in style to fur-
niture crafted in the Polish settlements of
Renfrew County, it boasts a cornice carved
in the Baroque manner.

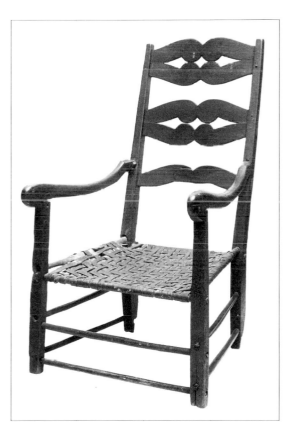

196 Chair

Anonymous
Niagara area, late 18th century
Painted wood
91 x 56 x 41 cm
*Niagara Historical Society Museum,
Niagara-on-the-Lake*

This striking arm chair is distin-
guished by its curved back slats
arranged in reversed pairs. Designed
in a style popular in Quebec during
the 18th century, it may have been
made in a French settlement in this
province.

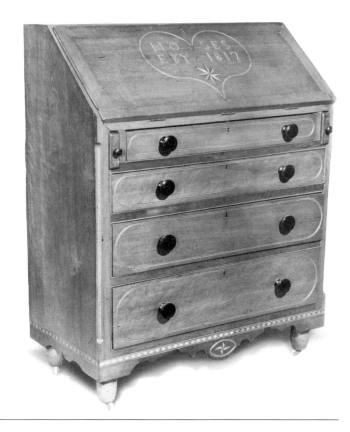

197 Desk
Moses Eby (1799-1834)
Waterloo County, 1817
Inlaid wood
127 x 101.5 x 50 cm
*Doon Pioneer Village,
Kitchener*

Among the most superbly crafted
pieces of Pennsylvania-German fur-
niture is this early cherrywood desk.
Elaborate inlay work appears on its
base and drawers, and the maker's
name and the date are enclosed
within a large heart on its lid.

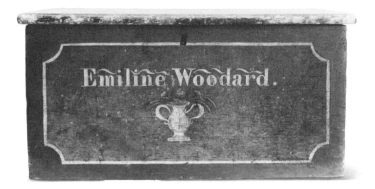

199 Storage Chest
Anonymous
Oxford County,
19th century
Painted wood
34 x 66 x 35 cm

Different motives led folk
artists to place names on furni-
ture: the desire to identify the
owner, to mark a dowry piece,
to sign a product. The motiva-
tion for rendering "Emiline
Woodard" on this finely paint-
ed chest remains a mystery.

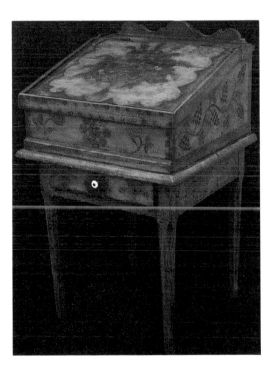

198 Desk
Anonymous
Iroquois, 19th century
Painted wood
99 x 60 x 56 cm
Upper Canada Village,
Morrisburg

This desk from eastern Ontario is a
beautiful example of the English tra-
dition in furniture decoration. The
large basket of flowers on its lid is
reminiscent of theorem paintings,
while the grapes and floral patterns
on the front and sides recall quilt
border designs.

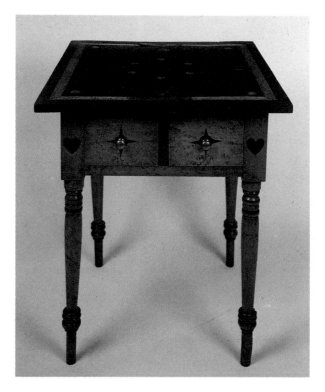

200 Table
Anonymous
Erbsville, 19th century
Inlaid wood
74 x 41 x 42 cm

This small maple table with dark hardwood inlay was reportedly made by a cabinetmaker from eastern Europe as a wedding present for his daughter. It is an amalgamation of styles; its refined form and decorative elements suggest both English and German design influences.

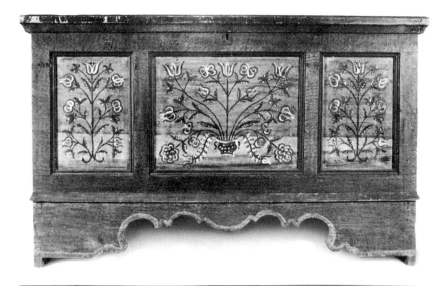

201 Storage Chest
Anonymous
Wilno area, late 19th
century
Painted wood
69 x 110 x 53 cm

This storage chest, one of several
made late in the 19th century in an
area of Polish settlement, illustrates
that community's perpetuation of
its folk art traditions. The floral
ornamentation painted freehand or
stencilled on its inset panels is typi-
cal of designs used in the Kaszuby
region in northern Poland.

Lenders to the Exhibition

Peter & Margaret Bell
Beth Tzedec Congregation, Toronto
Black Creek Pioneer Village, Toronto
Mr. & Mrs. Fred Blayney
Don & Joyce Blyth
Bill & Caroline Byfield
Ron & Wendy Cascaden
Mr. & Mrs. Fred Colborne
Conrad Grebel College, Waterloo
Mr. & Mrs. Jowe Creighton
Mr. & Mrs. Ross Cumming
Henry & Barbara Dobson
Doon Pioneer Village, Kitchener
Eva Brook Donly Museum, Simcoe
Mr. & Mrs. John Forbes
Collection of Hyla Wults Fox
John & Anne Hall
Rick & Holly Henemader
Don & Muriel Hoffman
William & Pauline Hogan
National Collection, Indian and
 Northern Affairs
Mr. & Mrs. Howard Jasper
Jordan Historical Museum of the
 Twenty, Jordan
Terry Kobayashi & Michael Bird
Natalie Korol

Mrs. Walter Korol
Marjorie E. (Sackrider) Larmon
Bruce & Gayle Malcolm
Jim & Marlene Miller
Collection of Ethel W. Moses
William Muysson
Niagara Historical Society Museum,
 Niagara-on-the-Lake
Nancy-Lou & E. Palmer Patterson
Bill & Jeanne Pattison
The Price Collection
Norma Rudy
Lloyd Ryder
Wolfgang & Carroll Schlombs
Joseph Schneider Haus, Kitchener
Jim & Marie Sherman
Mr. & Mrs. V. Smart
Robert & Brenda Starr
Upper Canada Village, Morrisburg
Mr. & Mrs. D. Alan Young

Selected Bibliography

Adamson, Anthony, and Willard, John. *The Gaiety of Gables: Ontario's Architectural Folk Art.* Toronto: McClelland and Stewart, 1974.

Barrett, Harry B. *Lore and Legends of Long Point.* Don Mills: Burns and MacEachern, 1977.

Bird, Michael S. *Canadian Folk Art: Old Ways in a New Land.* Toronto: Oxford University Press, 1983.

_____ . *Ontario Fraktur: A Pennsylvania German Folk Tradition in Early Canada.* Toronto: M.F. Feheley, 1977.

_____ . "Ontario Fraktur," *The Magazine Antiques* (September 1983), pp. 538-546.

_____ . "Perpetuation and Adaptation: The Furniture and Craftsmanship of John Gemeinhardt (1826-1912)," *Canadian Antiques and Art Review* (March 1981), pp. 19-34.

_____ . "Survival Transcended: Folk Art in Canada," *Canadian Collector* (September 1983), pp. 48-51.

Bird Michael, and Kobayashi, Terry. *A Splendid Harvest: Germanic Folk and Decorative Arts in Canada.* Toronto: Van Nostrand Reinhold, 1981.

Burke, Marguerite V. *The Ukrainian Canadians.* Toronto: Nelson, 1982.

Carpenter, Carole Henderson. *Many Voices. A Study of Folklore Activities in Canada and Their Role in Canadian Culture.* Ottawa: National Museums of Canada, 1979.

Celebration: The Marjorie Larmon Collection: 19th and 20th Century Folk Art in Canada. Windsor: Art Gallery of Windsor, 1982.

Conroy, Mary. *Canada's Quilts.* Toronto: Griffen House Press, 1976.

Contemporary Primitives. Kingston: The Agnes Etherington Art Centre, 1982.

Cumming, Mark. *The Group of One: Joseph Bradshaw Thorne.* Stratford: Cumming Publishers, 1981.

Dickason, Olive Patricia. *Indian Arts in Canada.* Ottawa: Indian and Northern Affairs, 1972.

Dobson, Henry, and Dobson, Barbara. *The Early Furniture of Ontario and the Atlantic Provinces.* Toronto: M.F. Feheley, 1974.

_____ . *A Provincial Elegance: Arts of the Early French and English Settlements in Canada.* Kitchener: Kitchener-Waterloo Art Gallery, 1982.

Dwyer, Ruth. *Mennonite Decorative Arts.* Hamilton: McMaster University Art Gallery, 1981.

Eastern Canadian Quilts and Hooked Rugs of the 19th and Early 20th Centuries. Uxbridge: Uxbridge-Scott Historical Society, 1978.

An Exhibition of Canadian Gameboards of the Nineteenth and Twentieth Centuries from Ontario, Quebec and Nova Scotia. Halifax: Art Gallery of Nova Scotia, 1981.

Fleming, Patricia. "In Search of the Work of William G. Loney, 1878-1956," *The Upper Canadian* (November/December 1983), pp. 29-30.

From the Heart: Folk Art in Canada. Toronto: McClelland and Stewart, 1983.

Gates, Bernard. *Ontario Decoys.* Kingston: Private Printing, 1982.

Good, E. Reginald. *Anna's Art.* Kitchener: Private Printing, 1976.

"Grassroots Arts," *Artscanada* (December 1969), entire issue.

Hall, Julie and Michael. "Decoys for the Folk Art Collector," in Paul A. Johnsgard. *The Bird Decoy.* Lincoln: University of Nebraska Press, n.d., pp. 10-12.

Hanks, Carole. *Early Ontario Gravestones.* Toronto: McGraw-Hill Ryerson, 1974.

Hansen, H.J., ed. *European Folk Art in Europe and the Americas.* New York: McGraw-Hill, 1968.

Harper, J. Russell. *A People's Art: Primitive, Naive, Provincial and Folk Painting in Canada.* Toronto: University of Toronto Press, 1974.

_____ . *People's Art.* Ottawa: National Gallery of Canada, 1973.

Heritage of Brant. Brantford: Art Gallery of Brant, 1977.

The Imaginary Portrait: The Work of Hertha Muysson. Kingston: Agnes Etherington Art Centre, 1974.

Kangas, Gene and Linda. *Decoys: A North American Survey.* Spanish Folk, Utah: Hillcrest Publications, n.d.

Ketubah: The Jewish Marriage Contract. Toronto: Art Gallery of Ontario, 1980.

Keywan, Zonia. *Greater Than Kings: Ukrainian Pioneer Settlement in Canada.* Montreal: Harvest House, 1977.

Kobayashi, Terry. "David B. Horst (1873-1965): St. Jacobs Woodcarver," *Waterloo Historical Society* (1977), pp. 78-92.

_____ . "Folk Art in Stone: Pennsylvania German Gravemarkers in Ontario," *Waterloo Historical Society* (1982), pp. 90-113.

_____ . "Fred G. Hoffman (1845-1926): Waterloo County Itinerant Woodcarver," *Waterloo Historical Society* (1981), pp. 111-126.

_____ . "Local Paintings Tour Canada: Ora C. Walper and J.J. Kenyon," *Waterloo Historical Society* (1974), pp. 26-29.

Kurelek, William. *The Polish Canadians.* Montreal: Tundra Books, 1977.

McKendry, Blake. *Folk Art: Primitive and Naive Art in Canada.* Toronto: Methuen, 1983.

McKendry, Ruth. *Quilts and Other Bedcoverings in the Canadian Tradition.* Toronto: Van Nostrand Reinhold, 1979.

McMurray, A. Lynn. "Ontario German Decorative Arts," in Donald B. Webster. *The Book of Canadian Antiques.* Toronto: McGraw-Hill Ryerson, 1974, pp. 128-142.

Murray, Joan. *Good Heavens: Conrad Furey, Lynda Lapeer, Gordon Law, George Steadman.* Oshawa: The Robert MacLaughlin Gallery, 1981.

Newlands, David L. *Early Ontario Potters: Their Craft and Their Trade.* Toronto: McGraw-Hill Ryerson, 1979.

Pain, Howard. *The Heritage of Upper Canadian Furniture: A Study in the Survival of Formal and Vernacular Styles from Britain, America and Europe, 1780-1900.* Toronto: Van Nostrand Reinhold, 1978.

Patterson, Nancy-Lou Gellerman. "Anna Weber hat das gemacht: Anna Weber (1814-1888): A Fraktur Painter of Waterloo County, Ontario," *Mennonite Life* (December 1975), pp. 15-19.

_____ . *Mennonite Folk Art of Waterloo County.* Waterloo: University of Waterloo Art Gallery, 1966.

_____ . *Mennonite Traditional Arts of the Waterloo Region and Southern Ontario: A Historical View.* Kitchener: Kitchener-Waterloo Art Gallery, 1974.

_____ . *Swiss-German and Dutch-German Mennonite Traditional Art in the Waterloo Region, Ontario.* Ottawa: The National Museum of Man Mercury Series, 1979.

_____ . *Wreath and Bough: Decorative Arts of Amish-Mennonite Settlers in Waterloo County.* Waterloo: Ontario-German Folklife Society, 1983.

Patterson, Nancy-Lou Gellerman, and Bird, Michael. *Primitive and Folk Art.* Waterloo: University of Waterloo Art Gallery, 1976.

Roth, Cecil. *Jewish Art: An Illustrated History.* Greenwich, Connecticut: New York Graphic Society, 1971.

Shackleton, Philip. *The Furniture of Old Ontario.* Toronto: Macmillan of Canada, 1973.

'Twas Ever Thus: A Selection of Eastern Canadian Folk Art. Toronto: M.F. Feheley, 1979.

Two Hundred Years Along the Grand. Brantford: Woodland Indian Cultural Educational Centre, 1984.

Ukrainian Canadiana. Edmonton: Ukrainian Women's Association of Canada, 1976.

Webster, Donald B., ed. *The Book of Canadian Antiques.* Toronto: McGraw-Hill Ryerson, 1974.

_____ . *Decorated Stoneware Pottery of North America.* Rutland, Vermont: Tuttle, 1971.

_____ . *Early Canadian Pottery.* Toronto: McClelland and Stewart, 1971.

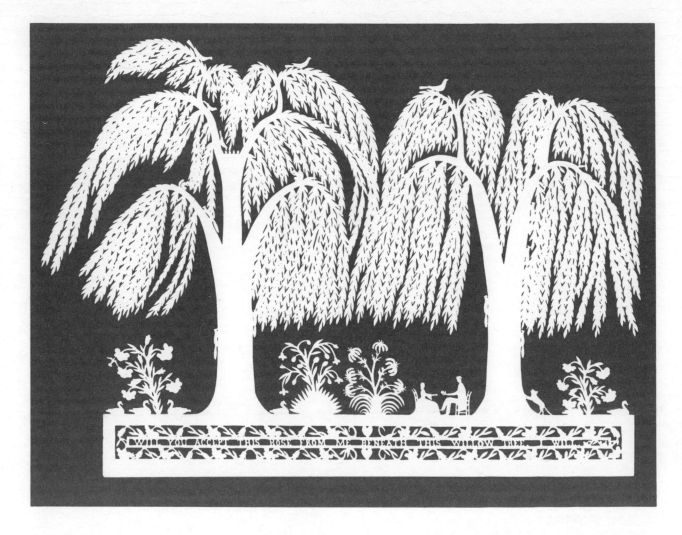